LEGENDARY LOCALS

— OF —

FORT WAYNE

INDIANA

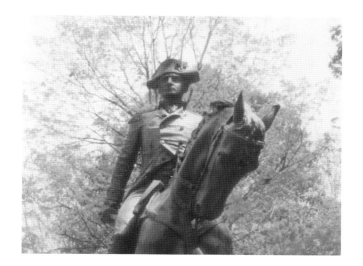

D1548214

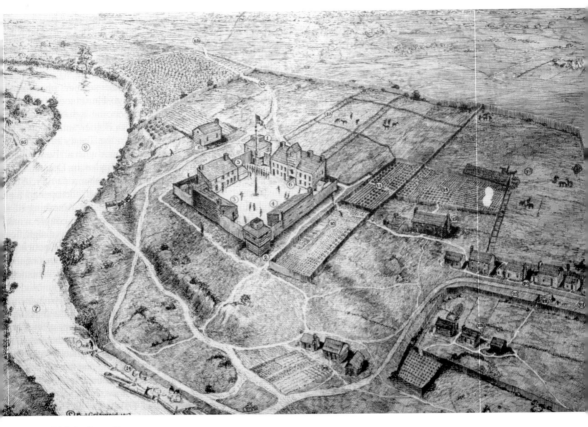

Whistlers Fort

Historian Bert J. Griswold created this image in 1917, deduced from 1815 drawings and other research of the third and final American fort in Fort Wayne. Built during 1815–1816, it was constructed under the direction of Maj. John Whistler. Decommissioned in 1819, the final remnants of the fort were razed in 1859. It is this Whistler's Fort that was reproduced on Spy Run Avenue and opened to the public on July 4, 1976. (Courtesy of ACPL.)

Page 1: Gen. "Mad" Anthony Wayne

This bronze equestrian statue of the city's namesake was sculpted by George E. Ganiere. Erected in Hayden Park at Maumee and Harmer Streets and dedicated on July 4, 1918, the statue of General Wayne astride his steed was relocated to Freimann Square in 1973. (Courtesy of Sue Sells.)

LEGENDARY LOCALS
OF

FORT WAYNE
INDIANA

RANDOLPH L. HARTER
AND CRAIG S. LEONARD

LEGENDARY
LOCALS

Legendary Locals is an imprint of Arcadia Publishing
Charleston, South Carolina

Printed in the United States of America

Library of Congress Control Number: 2015930128

For all general information, please contact Arcadia Publishing:
Telephone 843-853-2070
Fax 843-853-0044
E-mail sales@arcadiapublishing.com
For customer service and orders:
Toll-Free 1-888-313-2665

Visit us on the Internet at www.arcadiapublishing.com

Dedication

For the best parts of me: Pat, Nicholas, and Sarah

—Randolph Harter

For Sarah and Jane

—Craig Leonard

On the Front Cover: Clockwise from top left:
Kevin Leininger, journalist (Courtesy of the *News Sentinel*; see page 88), Arthur Roy Smith, pioneer aviator (Courtesy of ACPL; see page 88), Dr. Wendy Robinson, educator (Courtesy of the *News Sentinel*; see page 38), Carole Lombard, actress (Courtesy of ACPL; see page 100), Shelley Long, actress (Courtesy of the *Journal Gazette*; see page 102), Dick Stoner, magician (Courtesy of the *News Sentinel*; see page 82), Russ Choka, restaurateur (Courtesy of the *Journal Gazette*; see page 67), Ian Rolland, community leader (Courtesy of the *News Sentinel*; see page 79), Heather Headley, actress (Courtesy of the *News Sentinel*; see page 93)

On the Back Cover: From left to right:
Parkview Field and Tin Caps president Mike Nutter (Courtesy of the *Journal Gazette*; see page 124). Fort Wayne mayors, from left to right, (first row) Robert E. Armstrong (1976–1980) and Paul Mike Burns (1960–1964); (second row) Walter Paul Helmke Jr. (1988–2000), Winfield Moses Jr. (1980–1988), Ivan A. Lebamoff (1972–1976), and Graham Richard (2000–2008) (Courtesy of the *News Sentinel*)

CONTENTS

ACKNOWLEDGMENTS

Determining which 182 people to include in this book was not a task we took lightly, nor did we alone try to decide on those to be profiled. We began over a year prior to publication by assembling a list of about 350 current and prior citizens who had made their mark on the city. We then enlisted a number of reviewers with substantial knowledge in various aspects of Fort Wayne and its history and asked them to consider the listing, making suggestions for additions and deletions. We give grateful thanks to our reviewers for their critical insight and suggestions: Richard Schory, Michael Thomas, Tom Cahill, Faith Van Gilder, Amber Foster, Kevin Leininger, Blake Sebring, John Beatty, Dr. John Aden, Michael Poorman, Chad Gramling, Craig Miller, Bill Brown, Kevin Kilbane, Linda Smith, Nicholas Harter, and Sarah Arnold. Securing an image of each person to be profiled was a challenge, and in this endeavor we were fortunate to have the support of Laura Weston-Elchert and Kerry Hubartt at the *News-Sentinel*, Tom Pellegrene and Julie Inskeep at the *Journal Gazette*, John Beatty and Curt Witcher at the Allen County Public Library (ACPL), and Randy Elliott, Walter Font, and Todd Pelfrey at the Allen County Fort Wayne Historical Society (ACFWHS). We further appreciate images lent from a number of local families, and from companies whose founders we were profiling. In all the aforementioned cases, we have given courtesy image attribution. Unless otherwise noted, images are from the personal collections of the authors. The only step left was nine months of research and writing, and in this instance, we thank our local editor, Faith Van Gilder, for then improving this work. Thanks also go to our good friend John Beatty, Fort Wayne historian and genealogy department bibliographer at the ACPL who acted as our final reader and suggested a few changes. Some of the research required for this book is based on the work of others. In addition to those authors and books listed in the bibliography on page 125, we would like to thank the following: Tom Castaldi, Mark Neely Jr., Jim and Kathy Barron, Jason Smith, Dyne Pfeffenberger, Ralph Violette, John Martin Smith, Geoff Paddock, corporate and other websites, and numerous articles and publications written by professionals at the History Center, Allen County Public Library, *News-Sentinel*, *Journal Gazette*, and African/African American Historical Society Museum.

INTRODUCTION

In eulogizing the great local historian Bert Griswold in 1927, the *Fort Wayne News-Sentinel*'s editorialist noted that the Roman historian Tacitus had proclaimed, "The greatest office of history to be this: to prevent virtuous actions from being forgotten, and that evil words and deeds should fear an infamous reputation with posterity."

When Griswold published his *Pictorial History of Fort Wayne and Allen County* in 1917, it was the first attempt at a history of this area that had been made since Wallace Brice in 1868, nearly a half century earlier. While this work does not try to span such a gulf of years, it is now nearly a decade since the last comprehensive account of the history of Fort Wayne and Allen County was published. If anything, the pace of changes—especially in the social and economic realms—has accelerated in that decade, let alone in the last century. It is now impossible to imagine that a narrative that only recited the names and dates of the most prominent events, citizens, or public officials would be regarded as a complete account. Whole segments of the population that might not have formerly been regarded as the proper topics of a historical account cannot now be omitted without the omission itself casting serious doubt upon the comprehension or biases of the authors. The shorter works of history published in the last three decades are particularly notable for the number of businesses then regarded as anchors of the community that have completely disappeared, many without any remark in the daily news, let alone any later published narrative.

In setting out to write this account, we wanted to produce something that would in another 50 years be regarded as having stood the test of time. The easy part of this is referring to the earlier histories to discern the overall course that should underlie the narrative up to the recent past. Since this is not a conventional history, but a collection of biographies, the selection of historical personages has been a matter of keeping the general course of the story in mind while selecting the people whose lives and actions are associated with the specific events or general trends that make up the broader narrative or define the character of the era in which they lived. Only the introductory remarks at the start of each chapter approach the structure of a conventional account; much of the narrative is only implied by selection of the people profiled. The names of other individuals with whom a given person interacted or the institutions, events, or places where people profiled crossed paths are included as space allowed. In some cases, individuals not profiled are simply mentioned in the account of a figure with whom they interacted. To a great extent, this is somewhat like constructing the sort of narrative Edgar Lee Masters presented in his *Spoon River Anthology*, a cycle of poems in the form of the eulogies inscribed on the stones in the cemetery of the small town of Spoon River. In the course of perusing Masters' poems, the reader gathers facts and inferences that gradually form a mental picture of the history, society, and events that defined the times in which each of the subjects lived and the ways in which their lives intertwined with those of their contemporaries or influenced the lives of those who came after them.

The most daunting problem in assembling this collection has been that of trying to get a perspective on the recent past, particularly when deciding upon which living individuals to include. In some cases, this can take the relatively easy course of using a given individual to talk about an event or institution with which they are associated in the public mind. In some cases, the sheer number of such connections make a profile of a particular person indispensable. Nonetheless, an event or personage that seems of paramount importance in explaining today or the recent past may be utterly forgotten within a decade or so, depending upon the circumstances. Strictly speaking, every moment of every day is a part of history; how to separate the ephemeral from the significant? Here we have, frankly, had to make some (hopefully informed) guesses as to which of those living persons we could write about would have lasting importance. Even in fields for which performance statistics are kept (sports, entertainment), this can

be a dubious business, since today's record is always there to be either surpassed or simply forgotten. We can only assert that we have tried to make our choices without any agenda other than trying to select living persons to profile based upon as objective an assessment as we could muster and that our choices will stand the test of time.

It is also our hope that this brief account will pique the curiosity of readers to know more about the persons and events briefly summarized here by immersing themselves in the more complete sources noted in our bibliography and seeking out the living historians among us. And if we have also inspired some who read this to find the ways in which they can make their lives the stuff of future legends, so much the better.

CHAPTER ONE

Founders and Builders

Because of its importance as the north end of a portage trail that connected the Great Lakes to the Mississippi basin via portage and the Little Wabash River, the confluence where the St. Joseph and the St. Mary's Rivers form the Maumee River had long been inhabited. Other tribes came seasonally, but the Miami had a permanent settlement (Kekionga) and controlled the portage trade. The French were the first European visitors. The easiest way for the French to facilitate trade and establish colonial control was intermarriage with the leading clans of the Miami. By the time the British and Americans arrived, the Metis, as the French/Indians are now known, constituted the leadership of the tribe. When Anthony Wayne eliminated the Indians as a military threat in 1794, he made a fact of the British cession of the Northwest Territory to the United States that was agreed to at the end of the American Revolution. Subsequent federal policy toward the Indians varied, but the net effect was to create a local economy largely sustained by payments made to the Indians for land cessions. The annuities created a class of traders who supplied the Indians in return for hard currency.

In contrast to this were those who came to settle; they had little money, but their increasing numbers made them a political force as the area was organized. Adoption of removal of all tribes as federal policy in 1833 set the stage for the end of one era and the start of another in which canal and railroad construction caused a permanent shift in the character of the area from frontier outpost to nascent metropolis. The most successful figures to emerge from this era were those who realized the nature and causes of the changes that were taking place and capitalized on the opportunities that had developed.

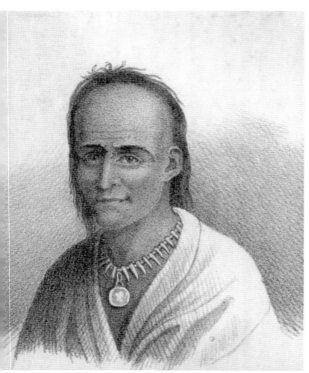

Little Turtle (c.1747–1812)

Me-she-kin-no-quah held the de facto position of war chief of the Miami. A brilliant strategist, he defeated two American armies, those of Josiah Harmer in 1790 and Arthur St. Clair in 1791 (the latter is still regarded as the worst defeat ever suffered by the US Army). But he saw that these victories were of transient value and counseled the tribe to make peace with the Americans. Having done so, he nonetheless led the Miami band at the Battle of Fallen Timbers in 1794; this defeat at the hands of Anthony Wayne ended the Miami as a military threat in the Northwest Territory. Little Turtle's prescience made him foremost among the Indians at the Treaty of Greenville. Though his home village was on Eel River in Whitley County, at the time of his death he was living at Kekionga and was given a full military funeral by the Americans. His grave, including a sword given to him by George Washington, was discovered on July 4, 1912; the site is now a park on Lawton Place. Several of the artifacts can be seen at the History Center. (Courtesy of ACFWHS.)

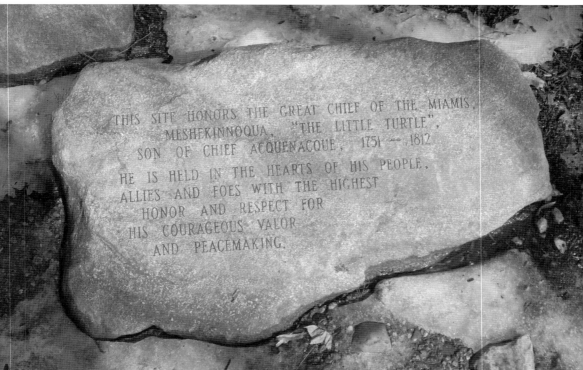

Gen. Anthony Wayne (1745–1796)
Nicknamed "Mad" because of his daring during the American Revolution, Wayne was the general President Washington turned to after two American armies had been wiped out by the Miami Confederacy under the command of Little Turtle in 1790 and 1791. Wayne assumed command of a new army, known as Wayne's Legion, at Pittsburgh, Pennsylvania, in 1792 and set about training them. In 1794, he marched north from Fort Washington (Cincinnati), finally confronting and defeating a combined force of Indians at the Battle of Fallen Timbers that year. He then marched to Kekionga and ordered the raising of a new post; its commander, Col. John Hamtramck, named it Fort Wayne. Wayne's skill as a diplomat at the Treaty of Greenville in 1795 is often obscured by his military success. In the treaty, the 12 tribes ceded to the United States the Ohio Territory and renounced control of the portage route through Kekionga, a vital route for trade between the Great Lakes and the Mississippi Valley. (Above image courtesy of ACFWHS; below image courtesy of the Library of Congress Geography and Map Division.)

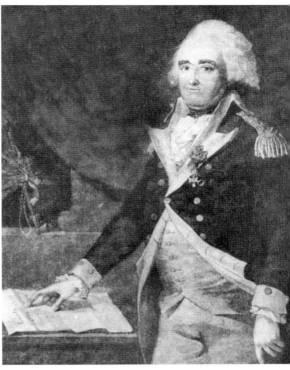

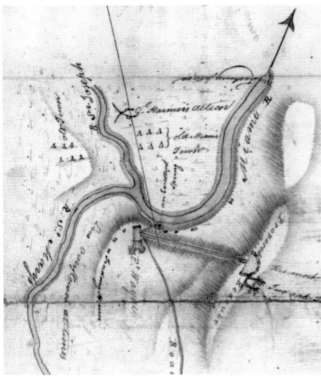

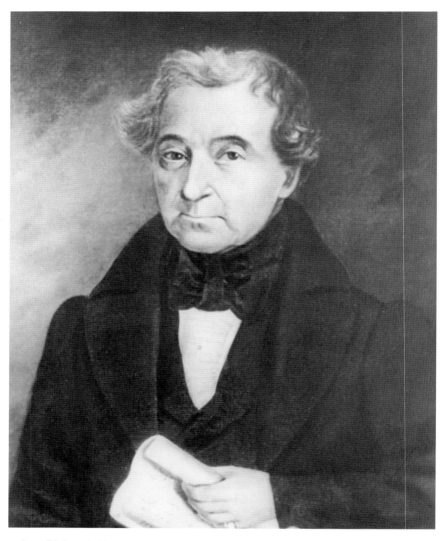

Jean Baptiste Richardville (1761–1841)
Richardville was the hereditary civil chief of the Miami. His position made him responsible for the overall welfare of his people, as well as master of the portage route across the Petite Prairie southwest of Fort Wayne. The portage tolls he collected reputedly made him the wealthiest Indian in America. He was half French and spoke that language and English fluently, as well as Miami; nonetheless, at treaty negotiations he would insist on speaking through an interpreter to have more time to formulate his responses. Through his treaty making, he secured lands for himself at the junction of every major tributary with the Wabash River and created a network of trading posts across the state. In the Treaty of 1826, he was one of a number of prominent Miami who were given a $600 brick house; Richardville put up an additional $1,600 and received a larger house that reflected his status. That 1827 house is now a National Historic Landmark owned by Allen County Fort Wayne Historical Society. He and Indian agent John Tipton formulated the Treaty of 1840, in which the Miami agreed to removal to Kansas, but with the proviso that he and other Miami who held land could remain. As a result, there are today more Miami in Indiana than there are elsewhere. His son-in-law Francis Lafontaine (1810–1847) succeeded him and forestalled removal for another five years via legal maneuvers. (Courtesy of ACFWHS.)

Julian Benoit (1808–1885)
In 1840, Benoit arrived in Fort Wayne, where he bought the land for the present cathedral square on Calhoun Street. He brought three nuns to Fort Wayne to found the St. Augustine Academy; their leader, Sr. Theodore Guerin, was canonized a saint in 2006. The school educated the children and grandchildren of Chiefs Richardville and Lafontaine. Benoit was coexecutor of their estates along with Catherine Richardville Lafontaine, daughter of one and wife of the other. Though exonerated, rumors that he mishandled these estates kept him from becoming bishop of the Fort Wayne Diocese. (Courtesy of ACPL.)

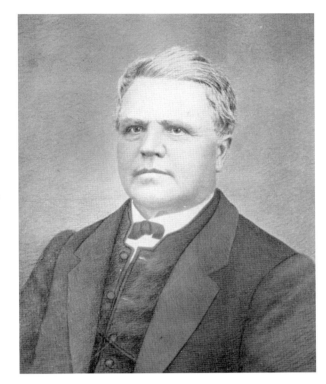

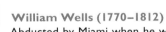

William Wells (1770–1812)
Abducted by Miami when he was 13, Wells married Sweet Breeze, daughter of Chief Little Turtle. He was torn between the native and white worlds. In 1792, he became a scout and interpreter for the Americans; he served Wayne at Fallen Timbers and Greenville. Congress gave Wells permission to take title to Kekionga, but he chose to simply live there as a Miami. After a stint as Indian agent at Fort Wayne, Wells died attempting to lead the Fort Dearborn (Chicago) garrison and settlers to safety in Fort Wayne. The Potawatomi reputedly ate his heart to gain his courage. Spy Run Avenue is named in his memory. (Courtesy of ACFWHS.)

Samuel Hanna (1797–1866)

Hanna personifies the transition of the frontier outpost to a thriving midcentury community. He arrived in 1824 to trade in furs but soon realized that greater things lay ahead. He bought large tracts of land throughout the Ohio Valley and became wealthy from the sale of city lots, especially after he was instrumental in bringing the Wabash and Erie Canal through the city (he actually rode to New York to buy surveying instruments to get the project started). When completed, the canal was the second-longest manmade waterway in the world. In 1844, Hanna built the city's first great mansion. As a result of the city's growth (and Hanna's consolidation of existing lines into the Pennsylvania Railroad), railroads arrived in 1855, and the city's future growth was assured. Hanna variously served as the city's first postmaster and as a judge. He also had extensive business investments, including a brief partnership with John Bass that launched what became the city's largest employer. (Both images courtesy of ACFWHS.)

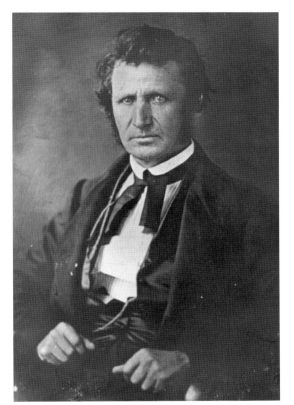

William G. Ewing (1801–1854)

Ewing was one of the most prominent traders with the Indians. Traders extended credit against annuities paid in gold and silver to the Indians. When the Miami went West, the Ewings set up posts there. In 1849, he built a Greek Revival house at the northwest corner of Berry and Ewing Streets (Ewing was worth approximately $14 million in modern dollars at the time of his death). The house was recorded by the Historic American Building Survey in 1934; it was demolished in 1963 for a car lot. The controversy led to passage of the city's first historic-landmark ordinance, in 1964. (Courtesy of ACFWHS.)

Allen Hamilton (1798–1864)

When Allen County was organized in 1823, Hamilton was appointed its first sheriff, but he is best known for his role as federal subagent to the Miami and confidant of Chief Richardville (of whose estate he was coexecutor with Julian Benoit). After the Miami agreed to removal in the Treaty of 1840 and Richardville's death the next year, Hamilton gained control of the chief's fortune and managed the affairs of his children. Through a series of fraudulent land deals, most of Richardville's assets became Hamilton's property; he used these assets to start the Hamilton National Bank. What had been Richardville's store on Columbia Street became Hamilton & Taber. (Courtesy of ACPL.)

15

William Rockhill (1793–1865)

Rockhill arrived in 1823 and was one of the first county commissioners that year. He platted 182 lots west of the Original Plat (now West Central). One of the grandest houses there was the Rockhill Mansion, an Italianate design built in the 1850s. At Broadway and Main Streets he built the Rockhill House Hotel; it was dubbed "Rockhill's Folly" because it was so far from downtown (though near the canal). The hotel later became St. Joseph Hospital. In 1848, Rockhill became the first county resident to serve in Congress. He was also a director of the State Bank of Indiana. (Courtesy of ACPL.)

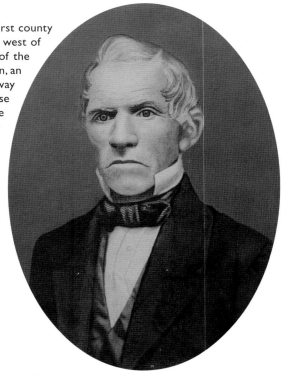

Jesse Williams (1807–1886)

After learning engineering in Ohio and also working on a canal there, Williams was appointed chief engineer of the Wabash and Erie Canal in 1832. Subsequently, he was also appointed to superintend all of Indiana's internal improvements (canals, turnpikes, and railroads). After the Wabash and Erie Canal was privatized in 1847, Williams oversaw its completion. Between 1865 and 1884, he platted his farm into the lots of Williams Addition, much of which is now the Williams-Woodland Park Historic District south of downtown. Creighton Avenue bears his wife's maiden name. The Williamses endowed City Hospital (Hope Hospital after 1891, now Parkview). (Courtesy of ACFWHS.)

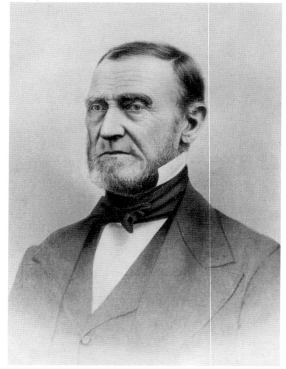

Hugh McCulloch (1808–1895)
He came West to practice law. Instead, he became an officer of the Fort Wayne branch of the State Bank of Indiana and head of the entire bank in 1855. In 1863, he became the first comptroller of the currency. Just before Lincoln's assassination, McCulloch became secretary of the treasury. He became a banker in London (1870–1875). In 1886, he gave a former cemetery to the city, now McCulloch Park. He is known as "father of the national banking system" for creating stable currency after the Civil War. His son and grandson were officers of the Hamilton National Bank. (Courtesy of ACFWHS.)

Henry Rudisill (1801–1858)
John Barr, a proprietor of the Original Plat, sent Rudisill to Fort Wayne to act as his agent. In 1830, Rudisill built a gristmill north of town on the west side of Spy Run, south of present-day State Street. His greatest contribution to the growth of the city was bringing in German Lutheran immigrants (to provide cheaper labor than he could hire locally to clear Barr's land). In 1837, he and Rev. Jesse Hoover founded the city's first Lutheran congregation. Rudisill succeeded Samuel Hanna as postmaster and is the namesake of a major street. (Courtesy of ACPL.)

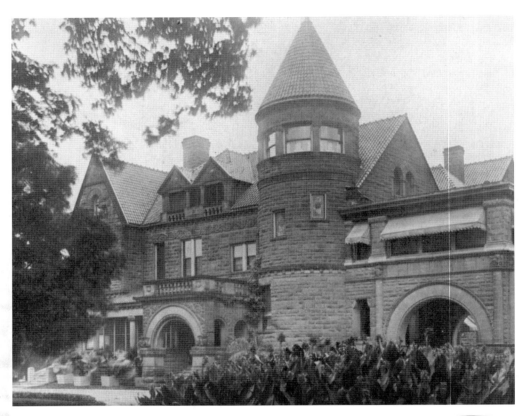

John Bass (1835–1922)

Bass was the foremost industrialist in Fort Wayne during the late 19th century. He arrived from Kentucky in 1852 and worked in his older brother Sion's machine shop. After his brother's death at the Battle of Shiloh, he formed a partnership with Samuel Hanna for the manufacture of iron castings. During the Civil War, they gained a virtual monopoly on the making of railcar wheels. Bass bought out Hanna in 1863 and started the Bass Foundry and Machine Co., which eventually extended for two miles along the railroad tracks on the south side of the city, covered 20 acres, and employed 2,500 people. He also had foundries at Chicago, Illinois, St. Louis, Missouri, Lenoir City, Tennessee (where he had coal mines), and Rock Run, Alabama (where he also had iron mines). Bass used his fortune not only to start the First National Bank but also to seed a number of other enterprises such as the Packard Organ Company, the Fox Bakery (later Nabisco), and the city's first trolleys and interurban railroads. Today he is best remembered for his palatial estate, Brookside, which is the centerpiece of the original campus of the University of St. Francis. When he died, he was worth the modern equivalent of $100 million. (Both images courtesy of ACFWHS.)

Ranald T. McDonald (1849–1898)
James Jenney came to Fort Wayne looking
for investors in an electric lighting system.
McDonald organized the Jenney Electric Light
Company in 1881, and Jenney's complete
light and power systems were sold nationally.
McDonald often retained partial ownership
of the plants as part of financing. In 1898,
his holdings included streetcar lines in
Fort Wayne, New Orleans, Louisiana, and
Indianapolis. The "Moonlight Tower" Jenney
arc lights in Dallas are restored landmarks.
In Fort Wayne, he was co-owner of the 1895
Elektron Building. In 1911, Jenney Electric
became the Fort Wayne Works of General
Electric, which once employed 20,000 people.
(Courtesy of ACFWHS.)

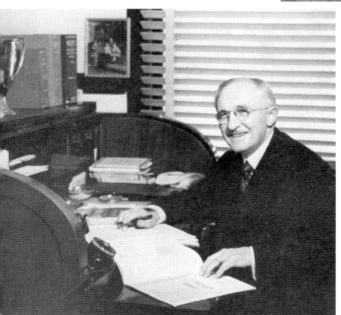

Theodore Thieme (1857–1949)
Perhaps inspired by the success
of Sam Foster, Thieme became
interested in hosiery making. The
best such technology was a German
state secret. Posing as an American
investor, Thieme bought machinery,
hired technicians, and spirited the
whole thing to America, founding
the Wayne Knitting Mills in 1891. A
progressive employer, he instituted
profit sharing and established a
Morris Plan (later Anthony Wayne
Bank). In 1922, he donated his
residence and art collection to house
the Fort Wayne Art School and
Museum. In 1923, he was outraged
when his handpicked board (including
the Foster brothers) sold out to
Munsingwear in his absence.

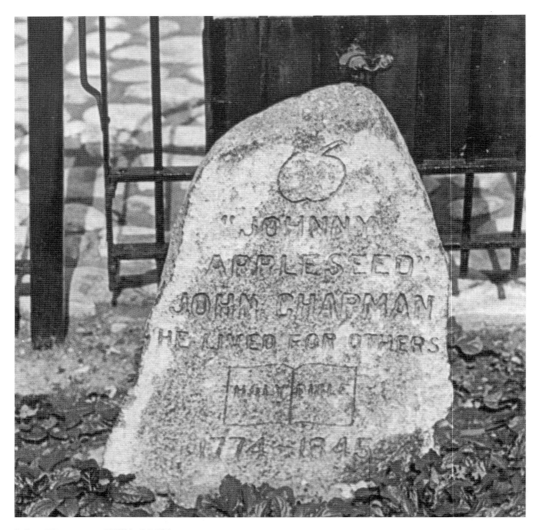

John Chapman (1774–1845)

A native of Massachusetts, John Chapman and his brother journeyed west to Pennsylvania in 1792 and later settled near Cleveland, Ohio (relatives still live there). In 1805, John left the farm to apprentice to an orchardist named Crawford; Chapman became an itinerant arborist who planted orchards and became known as "Johnny Appleseed," living on the money he made selling seeds and showing his customers how to grow them and build and operate cider mills. He used a provision of frontier law that allowed land to be claimed by planting 50 apple trees to acquire land in several states. At the time of his death, he owned more than 1,200 acres in several states. Nonetheless, the popular image of him as a threadbare barefooted vagabond is largely accurate. Many of his orchards survived into the 20th century, including one behind the Swinney House, where a plaque and boulder mark the spot. During Prohibition, many of the orchards were cut down by federal agents intent on eliminating cider making. Today, an apple tree that he reputedly planted 175 years ago still grows on a farm near Novae, Ohio, and grafts from it are available from several sources. Johnny Appleseed died in 1845 while on the Archer farm north of the city; his simple grave is on a knoll just south of the Memorial Coliseum. Each September, the site is the center of the Johnny Appleseed Festival, a celebration of pioneer life and crafts that draws crowds of a quarter million. (Courtesy of ACPL.)

David Foster (1841–1934)

David Foster came to Fort Wayne in 1868, and he had a successful furniture store. He was an original investor in Lincoln National Bank, the Anthony Hotel, and Lincoln Life Insurance Company. He was proudest of his civic efforts such as his 40-year association with Hope Hospital (now Parkview). In 1905, he was appointed one of the original park board members. During the 18 years he was board president, the park system grew from 98 to 506 acres. His statue was erected in Swinney Park in 1922. He and his brother Sam donated the 107 acres of Foster Park. (Courtesy of ACFWHS.)

Samuel Foster (1851–1935)

After several business ventures, including clerking in a dry-goods store, Yale Law School, newspaper publishing, and back into dry goods, in 1885 Sam Foster hit upon the idea of making collared ladies shirtwaists (blouses), an invention that made him a fortune. Besides the Samuel Foster Company, he used his wealth to invest in a number of other enterprises, including the Lincoln National Bank, Lincoln Life Insurance Company, Wayne Knitting Mills, and telephone companies in Fort Wayne, South Bend, Logansport, Anderson, and Muncie. In 1912, he and his older brother David Foster donated a 107-acre tract to the city for Foster Park. (Courtesy of ACFWHS.)

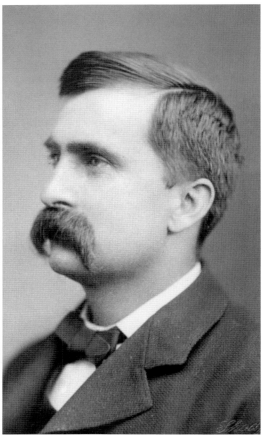

Perry Randall (1847–1916)

Randall was a lawyer known for mentoring young members of his profession. He also had a wide number of business interests, including organizing the city's first savings and loan association, the Tri-State, in 1888. He owned the Randall Hotel at Columbia and Harrison Streets, now Randall Lofts. His Randall Lumber Company provided oak for shipbuilding. In 1895, he organized and financed (with $7,000 of his own money) the city's centennial celebration. In his only political venture, he was defeated in the 1905 Democratic mayoral primary by William Hosey. When he died, unsolicited donations totaling $3,500 were made to build a memorial to him in Swinney Park. (Courtesy of ACFWHS.)

Charles Centlivre (1827–1894)

Centlivre founded the French Brewery in 1862 on Spy Run, opposite present-day North Side High School. In 1884, the brewery was rebuilt; in 1895 it was renamed Centlivre. The structure included a statue of Centlivre that now stands atop the Hall's Gas House Restaurant. Their nearby park grounds included a racetrack, beer garden, and boat rides; a trolley line ran downtown to transport customers. By 1918, the brewery's annual output was 30,000 barrels. After being a warehouse during Prohibition, the brewery reopened, was renamed Old Crown Brewery in 1961, and continued operating until 1973. Most of the brewery was razed by 1989. (Courtesy of Patricia J. Centlivre Bonahoom.)

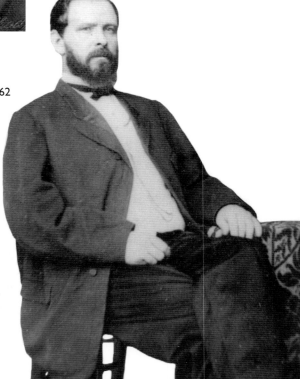

John Franke (1866–1927)

John Franke started Perfection Biscuit Company in 1901; at the time, he had a single oven in a building on Barr Street. By 1904, Perfection had relocated to Pearl and Ewing Streets, where it still operates. In 1910, he built the city's only Prairie house, designed by Chicago architect Barry Byrne (lovingly restored since the 1970s by architect Alan Grinsfelder). Franke chaired the building committee for the present Trinity English Lutheran Church in 1926; he also donated its $35,000 organ. In 1921, he gave 80 acres for Franke Park. John Franke's son-in-law H. Leslie Popp (1899–1986) led the company after 1927, when Franke died in an automobile accident. Popp introduced sliced bread locally and expanded operations to include interstate business and new product development. Popp was active in starting the city's first television station, WKJG, and the relocation of Methodist Hospital to a suburban location, where it opened as Parkview Hospital in 1953. As president of Perfection Bakeries, Inc., John Popp continues the business started by his grandfather. He has presided over expansion of the firm, which now operates seven bakeries in Indiana, Ohio, and Michigan and was renamed Aunt Millie's Bakeries in 2005. (Above image from *Builders of Greater Fort Wayne* by B.J. Griswold; below image courtesy of Craig Leonard.)

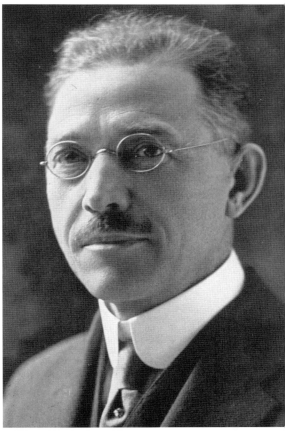

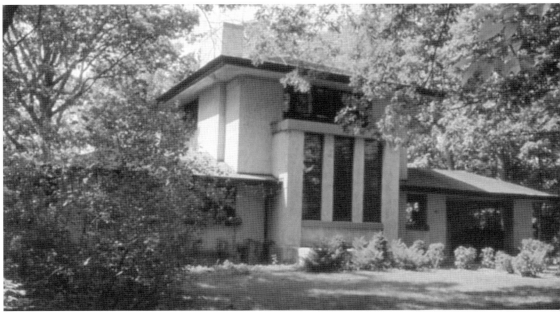

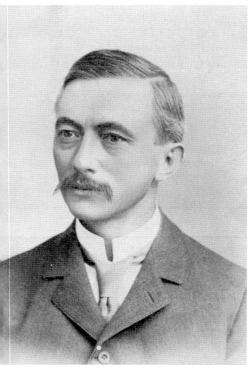

Henry Paul (1851–1933)

Paul's father was a canal-boat captain. Henry settled into building construction in 1875; in 1883 he and his half-brother John C. Peters moved the Horton Manufacturing Company to Fort Wayne from Bluffton. By 1888, he had enough capital to invest in the Salamonie Mining and Gas Company, which supplied the city with natural gas from 100 wells in Blackford County. When the wells played out, the company built a new plant on Superior Street (now Hall's Gas House Restaurant), and the company eventually became Northern Indiana Public Service Company. After the death of R.T. McDonald, Paul reorganized the Fort Wayne Electric Works and was its president from 1899 until 1905. By the turn of the 20th century, Henry Paul had become a central figure in the creation of local telephone service, interurban railroads, and manufacturing. His holdings were a virtual index of the enterprises of the era. As a banker, he reorganized several companies, including Jenney Electric, S.F. Bowser, Berghoff Products, and Perfection Biscuit. In 1925, Paul donated his Wayne Street home as the site for Trinity English Lutheran Church and built a new house on Forest Park Boulevard (pictured) that was designed by Marshall Mahurin. (Courtesy of ACFWHS.)

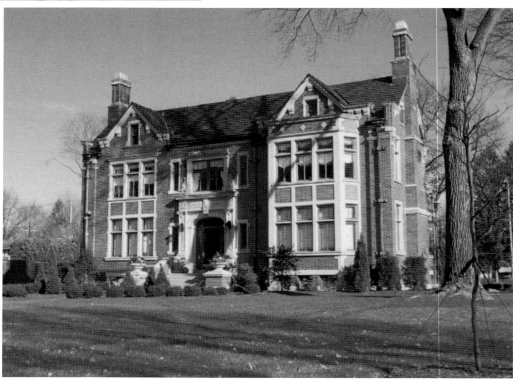

CHAPTER TWO

Public Figures and Community Leaders

By the end of the Civil War, Fort Wayne had become thoroughly connected to the outside world by trains, telegraphs, and mass media in the form of books, magazines, and newspapers. Further developments in electronic communication only reinforced and made more immediate the rate at which changes were both generally and locally felt as the city entered a new century. Going forward, the city would reflect both local conditions and the broader cultural, political, and economic trends of the United States as a whole. One of the best records of the nature of this process is the 1968 memoir *Myself When Young*, penned by Karl Detzer (1891–1987), in which he describes his childhood days, when the city's strong multiethnic character challenged the aspirations his progressive-minded parents had for broader horizons.

Many of the ethnic groups, such as the Germans who had fled the failed revolutions of 1848 or the spectra of forced military conscription, wanted to retain their ethnic identities, but their historical circumstances also translated into attitudes that were expressed in local politics that stressed frugality of public expenditure and skepticism toward some aspects of the outside world. The success of public figures would often depend upon the extent to which they could simultaneously navigate between the nature of Fort Wayne as a place dominated by well-established norms and the pressures for change that were necessitated by circumstances beyond the community's immediate control. Some people also became public figures by being the first to locally embrace social or technological change, either as innovators in their fields or by becoming the local exemplars of larger, more general cultural or technological developments.

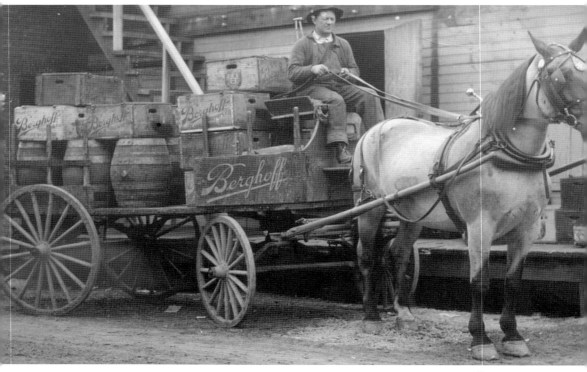

The Berghoff Brothers

The Berghoff brothers (Herman, Henry, Hubert, and Gustave) came from Dortmund, Germany, to Fort Wayne in 1870. They bought a brewery in 1882 and renamed it the Herman Berghoff Brewing Company in 1887. In 1893, Herman took their beer to exhibit at the world's fair in Chicago; he stayed there and opened the Berghoff Restaurant, which operated well into the 20th century. Back in Fort Wayne, Gustave took over the brewery, but in 1892 he also bought Summit City Soap Works (later Rub-No-More), selling it to Procter & Gamble in 1921. The Berghoffs had several businesses under the names Berghoff Products and later Wayne (Wayne Oil Burner, later renamed Wayne Home Equipment, Wayne Rubber, Wayne Plastics). Wayne Home Equipment still makes furnace burners in Fort Wayne. Health problems caused Hubert to leave the brewery in 1908. Henry (pictured right) became mayor in 1901, and he oversaw the creation of the first park board, appointing, among others, David Foster. In 1905, Henry and Gustave Berghoff were among the founders of the German-American Bank (Lincoln National Bank). At the onset of Prohibition in 1918, Berghoff produced 180,000 barrels of beer annually. Production resumed in 1933; in 1954, the company was sold to Falstaff, which operated it until 1990. (Above image courtesy of ACPL; right image courtesy of ACFWHS.)

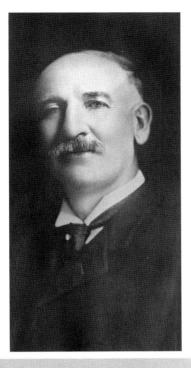

William Hosey (1854–1937)

Hosey served as mayor for 17 years in four nonconsecutive terms between 1905 and 1934. Though his formal education ended at age 10, Hosey read extensively and became a machinist in the Pennsylvania Railroad shops. He studied the city's administration and used his phenomenal memory to gain an encyclopedic knowledge of the city's public works. As a city councilman, he advocated public ownership of utilities; during his first mayoralty, a city power plant was built.

Economy and low taxes were always Hosey's watchwords; he resisted annexations to the city if the extension of city services would not be paid for by taxes in the new areas. But as the city grew, Hosey oversaw extension and upgrading of streets and utilities. Construction of railroad-track elevations in the city also began. Though he was an advocate of well water, in Hosey's fourth term (1929–1933) construction of a new water-filtration plant began. Ironically, it was his crowning achievement: it marked the end of wells as the city water supply (they could no longer satisfy demand). The project was financed by a $2.5-million bond issue paid for by water revenues. Another significant project of Hosey's was replacement of the city power plant (now Science Central), finished in 1934. (Left image courtesy of ACFWHS; below image courtesy of ACPL.)

Harry Baals (1886–1954)

Fort Wayne's only four-consecutive-term mayor assumed office in 1935, during the depths of the Great Depression. In order to preserve the low tax rates of his predecessor, Baals applied for federal grants from the Works Progress Administration and the Public Works Administration; the city received $6.5 million for public works projects. In the spring of 1936, the city was recovering from the worst winter in 40 years and resulting water-main breaks. City attorney Walter E. Helmke had settled 36 typhoid fever–damage suits against the city the previous year; improved lines avoided another typhoid outbreak. Like Mayor Hosey, Baals' formal education had been cut short at 15; he went to work at Fort Wayne Electric and took a correspondence course in electrical engineering. He spent 21 years at General Electric. From 1922 until 1930, he was postmaster. In 1947, Mayor Baals took steps to start the project for which he is best remembered, the elevation of the Nickel Plate (now Norfolk Southern) railroad tracks across the north side of downtown. Completion of this project in 1955 led to the explosion of northward growth along the California Road (now Coliseum Boulevard). (Right image courtesy of ACFWHS; below image courtesy of the *News-Sentinel*.)

Ivan Lebamoff (1932–2006)

Republican dominance of city politics waned when Ivan Lebamoff became Democratic Party chairman. A tireless campaigner, Lebamoff rebuilt the party and in 1971 was elected mayor. The City Light Plant was only meeting about a fourth of the city's needs when Lebamoff negotiated a 35-year lease of the city's plant to Indiana & Michigan Power for $1 million a year. Downtown, where the site of the 1919 Wolf & Dessauer department store had been an eyesore since 1962, Summit Square, a 32-story tower, was completed in 1981. Lebamoff instituted collective bargaining for city employees and created the women's bureau and the senior citizens' center. (Courtesy of the *News-Sentinel*.)

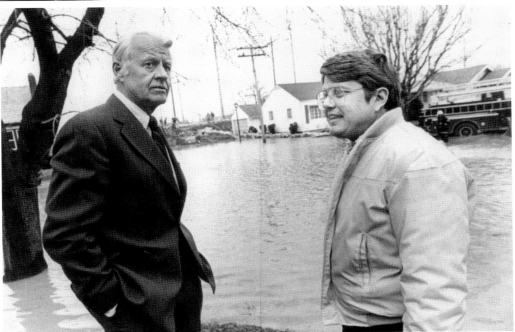

Winfield "Win" Moses Jr.

Moses rode a utility-fighting reputation to the city council (1971–1979) and mayor's office (1980–1987). In 1980, National Urban League president Vernon Jordan was shot in Fort Wayne. Moses and city leaders managed racial tensions and a national media onslaught. In 1982, national journalists returned for Fort Wayne's worst-ever flood and welcomed President Reagan to the "City That Saved Itself." After losing a bid to keep International Harvester, Moses's economic developers landed the massive General Motors plant. Moses, pictured at right with Gov. Bob Orr, later served five terms as a state representative (1992–2012). (Courtesy of *Journal Gazette*.)

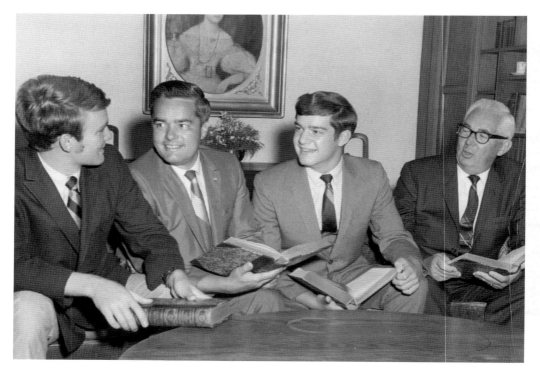

The Helmkes

The Helmke family (above, from left to right, Paul, Walter P., Mark, and Walter E.) has been prominent in the public life of Fort Wayne and Allen County for most of a century. Walter E. Helmke (1901–1976) joined the local bar in 1925 and subsequently served as county prosecutor (1928–1932); he was city attorney during the first Baals administration (1935–1948). As a trustee of Indiana University, Walter E. worked with Purdue trustee Arthur Kettler to create a joint campus for the two schools at Fort Wayne in 1964. Besides serving as longtime city attorney and Republican County chairman, Walter E. was instrumental in preventing demolition of the Allen County Courthouse in the early 1970s to provide a parking lot for the City-County Building; instead, the building was cleaned and generally refurbished.

Like his father, Walter P. served as county prosecutor (1962–1970); he was also a state senator (1970–1974) and in 1971 was voted Best Rookie among new members of the legislature. Walter P. was instrumental in orchestrating bar-association support for the 1995–2002 restoration of the Allen County Courthouse and the creation of the Allen County Courthouse Preservation Trust, which largely funded the work. Walter's sons Paul and Mark were also active in public life in different ways.

Paul was mayor of Fort Wayne from 1988 until 2000. During his tenure, the redevelopment of downtown proceeded with the completion of the Grand Wayne Center and Midtowne Crossings projects and the construction of Headwaters Park and the Courthouse Green. Through major annexations, the city's area was increased by 50 percent, adding areas primarily to the north and west. He also served as president of the US Conference of Mayors. After his mayoralty, Paul was CEO/president of the James Brady Center to Prevent Gun Violence. He is now director of the Civic Leaders Living/Learning Center at Indiana University Bloomington, where he was the student-body president in the late 1960s. Mark (1952–2014) had a brief career in journalism at the News-Sentinel before becoming press secretary to US senator Richard Lugar and later a member of the staff of the Senate Foreign Relations Committee Lugar chaired. In that capacity, he was involved in the dismantling of the Soviet Union's nuclear arsenal and the transition to democracy in the Philippines. He later headed his own political consulting firm and most recently taught public policy at Trine University in Angola, Indiana. (Courtesy of Paul Helmke.)

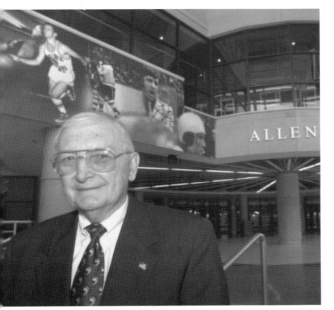

Edwin "Ed" Rousseau (1933–2009) Businessman and civic leader Ed Rousseau was embroiled in city and county politics for over 40 years. He was a Fort Wayne city councilman for eight years, county council member for 14, and county commissioner for 16. The original manager of Glenbrook Square, local realtor and appraiser Rousseau was considered a county commissioner to be reckoned with—someone who did not mince words. He championed the creation of the Metropolitan Human Relations Commission, Allen County income tax, renovation and expansion of Memorial Coliseum, and construction of the airport expressway and City-County Building, since renamed in his honor. (Courtesy of the *News-Sentinel*.)

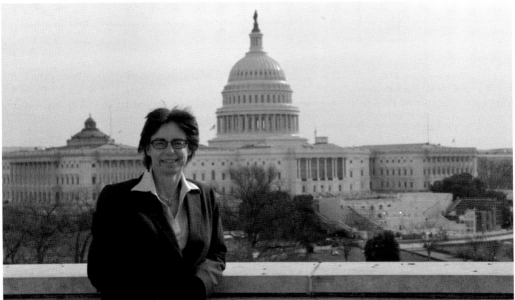

Cosette R. Simon
A director of the Fort Wayne YWCA, Simon later worked for Evan Bayh when he was governor and US senator. In 1985, when she was city comptroller, Democratic mayor Win Moses resigned his office and pled guilty to a misdemeanor to settle a financial reporting error in his reelection campaign. Simon famously was appointed Fort Wayne's first female mayor, on an interim basis. When Democratic precinct committeepersons reelected Moses 11 days later, Simon completed the city's shortest mayoral term ever. She later became a Lincoln National executive and then joined SwissRe; she opened the Washington, DC, office and became senior vice president of government relations and public policy. (Courtesy of the *Journal Gazette*.)

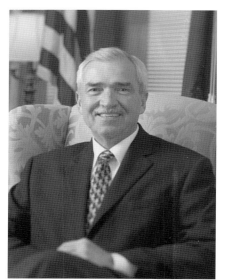

Thomas "Tom" Henry

Mayor since January 2008, Henry is seeking a third term in 2015; if successful it will make him the first three-term Democratic mayor in the city's history. Previously a five term Third District council member from 1984 to 2004, accomplishments during his tenure have included the settlement agreement between the city and Indiana Michigan Power and acquisition of Aboite's Aqua Source. Also, he has overseen new downtown development with Ash Plaza, Randall Lofts, the Harrison, Cityscape Flats apartments, Anthony Wayne condominiums, the award-winning Dr. Martin Luther King Jr. Bridge, additional parks, recreational facilities, trails, and planning for redevelopment of the Landing on Columbia Street. (Courtesy of City of Fort Wayne.)

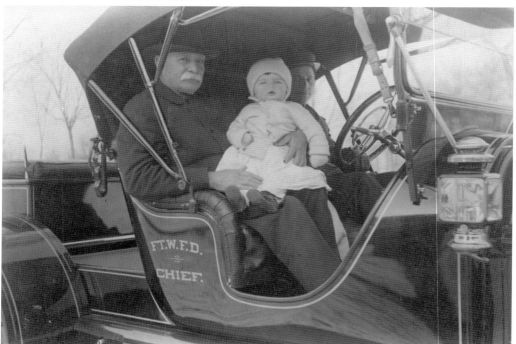

Henry Hilbrecht Jr. (c.1854–1925)

In 1839, the town of Fort Wayne purchased its first rudimentary hand-pumped fire engine and a two-wheeled hose cart with 500 feet of leather-riveted hose, both of which arrived by canal boat. However, it was not until 1882 that the first full-time fire chief was hired, Henry Hilbrecht Jr., who would be the driving force for over 30 years behind building the city's modern fire department. Overseeing construction of nine fire stations and the hiring and equipping of firemen, he is pictured here in his new 1913 Speedwell fire chief's car. Fire station No. 3, built in 1893 (now the Fire Fighters Museum) was one of those built under his direction. (Courtesy of ACFWHS.)

Henry Lawton (1843–1899)

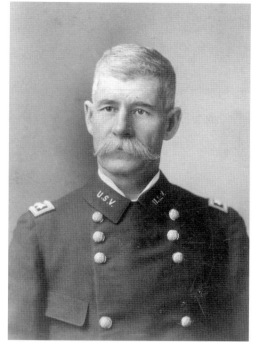

Lawton regarded Fort Wayne as home, though his career kept him elsewhere. In 1861, he joined the 9th Indiana Infantry; by war's end he was a colonel. Lawton was in the 1886 campaign that captured Geronimo, and in 1893, he received the Congressional Medal of Honor for service in 1864. In 1898, Lawton trained troops for the Spanish-American War, but he never saw combat in Cuba. On December 18, 1899, Henry Lawton was killed by a sniper in the Philippines. A park on Clinton Street is named after him; in 1921 he was further honored with a statue in Lakeside Park. (Courtesy of Mark Weldon.)

Homer VanMeter (1905–1934)

He was Fort Wayne's gangster. A train robber at 19, he met John Dillinger in prison; both were paroled during a general amnesty and returned to thievery. In 1934, VanMeter was with Dillinger during a shoot-out in which two federal agents died. VanMeter met his fate in St. Paul, Minnesota, in 1934. His body was returned to Fort Wayne for burial by his brother, who had his own problems: police confiscated a car that Homer had given him. He was allowed to keep it for lack of proof the vehicle was stolen. Homer VanMeter is said to haunt those who visit but do not leave coins on his grave.

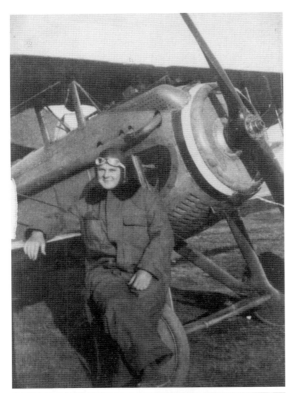

Lt. Paul F. Baer (1894–1930)
Eager to serve as a fighter pilot in World War I, Baer enlisted in the Franco-American Flying Corps in 1917. In 1918, he transferred to US Air Service's 103rd Aero Squadron. America's first ace, with nine kills to his credit, he was shot down in the spring of 1918 and spent the rest of the war in a German prison camp. Baer later helped form mail and passenger service in China and was killed in Shanghai when the floatplane he was flying hit the mast of a Chinese junk and flipped as he attempted to take off on the Yangtze River. (Courtesy of ACFWHS.)

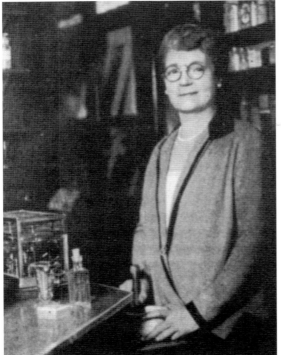

Julia Emanuel (1871–1962)
Julia was the only woman to graduate in a class of 41 at the University of Michigan School of Pharmacy. She had to stay out of sight at work so that customers would not know a woman was filling their orders. In 1902, she opened her own shop in Fort Wayne. Two decades later, she and Dr. L. Parke Drayer put up a building at 123 West Wayne Street; half of the first floor was occupied by Miss Emanuel's Chemist Shop. She only hired female college graduates, and she always wore one yellow and one blue anklet, the colors of her alma mater. (Courtesy of ACPL.)

Arthur "Art" Smith (1890–1926)

Born in Fort Wayne, Smith attended Central High School and grew up with an inquisitive mind and a yearning to build an airplane and fly. At age 19, Art's parents mortgaged their home to raise the $1,800 he felt he would need to accomplish the feat. During the first flight over what is now Memorial Park, the plane nosedived and crashed, starting his trail of nicknames that included the Smash-Up Kid, Fort Wayne's Bird Boy, and the Loop the Loop Kid. Art would go on to build other planes, fly from the Fort Wayne Driving Park near State Boulevard and North Anthony Boulevard to the thrill of local residents, and barnstorm across the country from one fairground and horserace track to the next. On October 26, 1912, he famously eloped with his girlfriend, Aimee Cour (pictured), secretly flying from the Driving Park to Hillsdale, Michigan, to be married. He crash-landed the plane just outside Hillsdale, and while banged up, they were married in the hospital. The pinnacle of his fame came during the 1915 Panama-Pacific International Exposition in San Francisco, where over the year he was the featured entertainment. Over six million people watched in awe as the novel machine piloted by the diminutive five-foot, three-inch Smith gave two shows per day, with flares attached to the wings during the evening event. In 1916 and 1917, underwritten by the Japanese government, Smith made two trips to Japan, giving flying demonstrations throughout the country. During World War I, Art trained pilots for the US government, acted as a test pilot, and worked on various innovations for airplanes. He joined the US Post Office, flying early airmail routes in 1923. During a snowstorm on the night of February 12, 1926, he crashed his Curtiss Carrier Pigeon into a grove of trees near Montpelier, Ohio, and died instantly. Fort Wayne citizens were devastated to hear that their hero, whom they had followed through the newspapers for years, had died. A public groundswell of contributions took place, and two years later, in 1928, the soaring bronze statue the *Spirit of Flight* was dedicated to him atop a 40-foot shaft of granite in Memorial Park, where he first flew. (Courtesy of ACPL.)

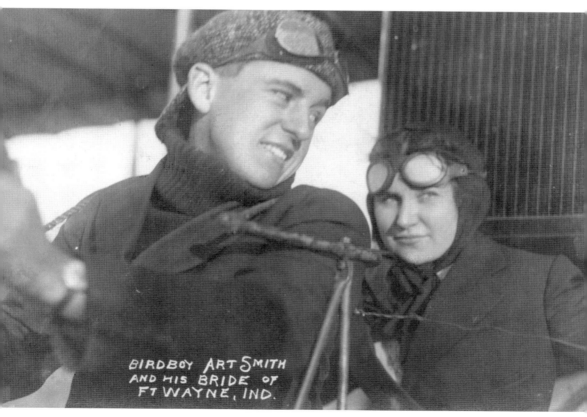

BIRDBOY ART SMITH AND HIS BRIDE OF FT WAYNE, IND.

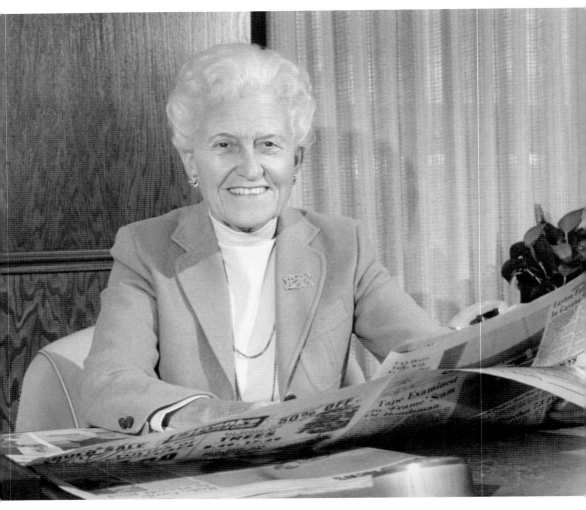

Helene Foellinger (1910–1987)
When her father died while on a hunting trip in 1936, Helene Foellinger became the youngest newspaper publisher in the country at age 25. Her father, Oscar Foellinger (1885–1936), had created the *News-Sentinel* and built it into one of the highest circulation papers per capita in the country. In her 45-year career as a publisher, Foellinger increased the paper's circulation a further 30 percent. In 1950, she ensured the future financial health of both the city's newspapers by creating a joint operating company, Fort Wayne Newspapers; in 1958, their joint headquarters on Main Street was completed. In 1980, she sold the *News-Sentinel* to Knight-Ridder and devoted herself completely to philanthropy. In 1958, she built the Foellinger Theater in Franke Park as a memorial to her father; Foellinger restored and expanded another theater at her alma mater, the University of Illinois. She also funded the Foellinger-Freimann Botanical Conservatory. With assets of approximately $175 million and under the direction of Cheryl Taylor, the Foellinger Foundation today continues Helene Foellinger's family legacy of community service in Allen County. (Courtesy of the *News-Sentinel*.)

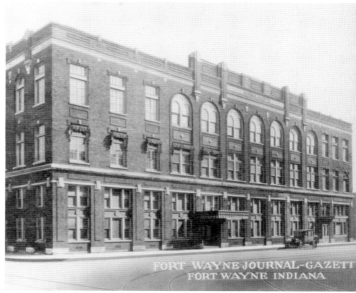

FORT WAYNE JOURNAL-GAZETTE
FORT WAYNE INDIANA

Richard Inskeep (1924–2014)

Inskeep (seen above between his wife, Harriett, and daughter Julie) joined the staff of the *Journal Gazette* in 1949. One of its owners, his wife's uncle Virgil Simmons, asked him if he would like to be in the newspaper business. Inskeep thought he would primarily be an accountant; his first job was making a complete physical inventory of the paper's assets, down to the reporters' pencils. This aided Simmons in restructuring the paper's operations in the first year of the joint operating agreement with the *News-Sentinel*. It was also the start of Inskeep's apprenticeship; by the time he became publisher in 1973, he had worked in virtually every part of the paper's operation. That same year, the joint operating agreement was up for renewal, and he decided that the *Journal-Gazette* might need to return to independent production in order to grow. But, when the *News-Sentinel* was sold in 1980, its new owner, Knight-Ridder, offered favorable terms, and the idea was dropped. By the time he handed the publisher's chair to his daughter Julie in 1997, the *Journal Gazette* had become the city's largest circulation newspaper. Both father and daughter are members of the Indiana Journalism Hall of Fame, and their Journal Gazette Foundation has disbursed over $10 million. Inskeep directed the restoration of the paper's original building at Clinton and Main Streets, where the paper's executive offices are still located. (Left image courtesy of the *Journal Gazette*; right image courtesy of ACPL.)

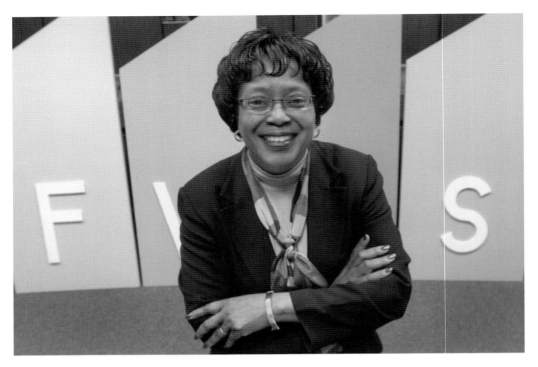

Dr. Wendy Robinson

Senior-class president Wendy Sanders was voted the Girl Most Likely to Succeed at Central High School in 1969, and succeed she has. She earned degrees from DePauw, Indiana University, and Ball State, and in her 35-year career with Fort Wayne Community Schools has held roles including teacher, assistant principal, administrator for the Wayne High School zone, assistant superintendent, deputy superintendent, and since 2003, superintendent. Today, with a staff of 4,000, she oversees 51 schools, educating over 30,000 students a year. The tireless advocate for education has received numerous awards and is responsible for the largest school corporation in Indiana. (Courtesy of the *News-Sentinel*.)

Irene Walters

Arriving in town with her husband, freshly minted attorney Bob Walters, in 1966, Irene Walters dived into local nonprofit and community projects as a leader or champion of each cause. She spent 19 years as executive director of university relations for IPFW and masterminded the 40th-anniversary Mastodons on Parade Community Art Project and the Tapestry—A Day for Women series. Walters, along with others, founded Francine's Friends mobile mammography project, Kids Crossing playground, Women United, and Riverfest, to name but a few. As a mayoral appointee, she became the executive director of the Fort Wayne's 1994 bicentennial celebration council and later served as cochair of the city's millennium celebration. (Courtesy of the *News-Sentinel*.)

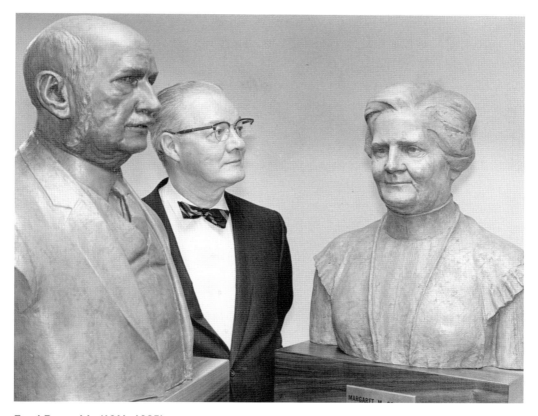

Fred Reynolds (1911–1995)

Reynolds began working at the Allen County Public Library in 1930 as a bookmobile driver. He eventually got a degree in library science and became library director in 1959. There were 155,000 books in the library in 1930; by the time he retired in 1979, there were about 1.7 million in a county-wide system. But his most unique contribution was the creation of what has become the second-largest historical and genealogical collection in the country. The collection began in 1961 with 400 books from the local DAR chapter. In 1965, Reynolds began to grow the collection by centralizing all existing related library materials in the collection and buying microfilm of the US census. In 1965, agreements secured deposit of city directories from across the country. Then, a program of copying collections from other libraries in exchange for circulation copies for the donors began with the Newberry Library in Chicago. About 30,000 volumes were copied from Newberry; this success led to similar arrangements with other libraries and historical societies across the country. When the new building opened in 1968, he commissioned busts of his predecessors Margaret Colerick and Rex Potterf (pictured) in the building as part of a large collection of busts commissioned from local sculptor Hector Garcia. The new building that opened in 1968 was expanded in a project completed in 1981; in 2007, another major expansion was completed under library director Jeff Krull, as well as a major overhaul and expansion of the branches, which was funded by the largest bond issue in county history. The Reynolds Historical Genealogy Collection is a major attractor of out-of-town visitors to Fort Wayne, as well as having a major presence on the Internet that includes the Lincoln Financial Collection of documents and images formerly in the collection of Lincoln Life National Insurance Company. The further growth and management of the genealogy collection in recent years has been under the direction of Curt Witcher, genealogy center manager and senior manager of special collections. (Courtesy of ACPL.)

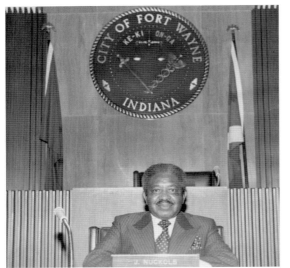

John Nuckols (1914–1982)
Inner-city barber and first African American elected to the Fort Wayne City Council, Nuckols won his first election in 1959, beginning his more than 22 years in office. Representing the First District, at the time of his death he was the longest-serving city councilman in the entire country and a vehement advocate for minority rights. During the Armstrong administration, he sued the city for its lack of minority hiring. The federal government agreed with Nuckols, ordering the city to comply with federal hiring guidelines for women and minorities. Nuckols Memorial Park at Jefferson Boulevard and Harmar Street is named in his honor. (Courtesy of Loretta J. Johnson.)

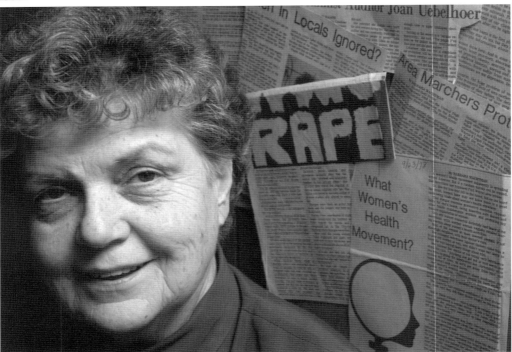

Joan D. Uebelhoer (1928–2012)
Cofounder of Fort Wayne Feminists, Uebelhoer was a well known and vocal advocate of civil rights for women and the poor, a staunch pro-choice proponent, and an antiwar activist. A teacher for many years, she taught at Forest Park Elementary, St. Henry's Elementary, and Bishop Luers High School. She started the women's studies department at IPFW and was associate professor from 1977 to 1989. In addition to being cofounder of Daybreak Crisis Homes for children, she was director of the Allen County Department of Welfare and a director of Planned Parenthood of Allen County. (Courtesy of the *News-Sentinel*.)

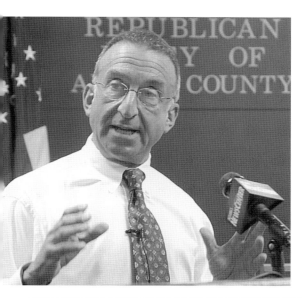

Steven R. Shine
Shine was South Side senior-class president, has Indiana University degrees in political science and telecommunications, and earned a law degree from Ohio Northern University. His baritone voice first went on the air with WOWO at age 10. Shines lifelong hobby of broadcasting includes founding radio station WBWB in Bloomington during college, then Fort Wayne's Sunny 106.3, and on-air duties at WFFT-TV for 21 years. In addition to his law practice, which includes membership in the Federal Communications Bar Association, Shine has been chairman of the Allen County Republican Party since 1993. A champion for the Broadway corridor, he originated the annual Christmas on Broadway tree and celebration in 2004. (Courtesy of the *News-Sentinel.*)

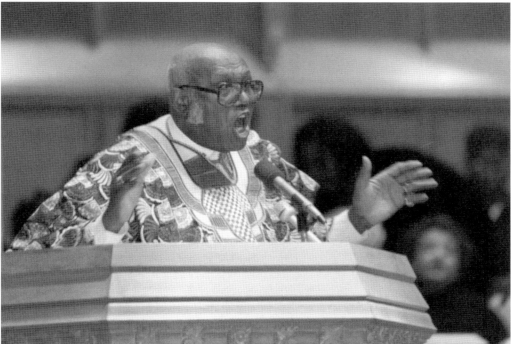

Rev. Jesse White (1927–2001)
Pastor and founder of True Love Missionary Baptist Church, White received local and national praise for being Fort Wayne's leading civil-rights leader for nearly 50 years. As head of the Council of Civic Action, he brought Operation Breadbasket to the city and was renowned for his civic service and activism. White's deep booming voice led marches against discriminatory hiring at banks, supermarkets, and retailers. In 1969, racial segregation prompted him to boycott Fort Wayne Community Schools, as 1,300 children attended "freedom schools" at local churches for nine days. (Courtesy of the *News-Sentinel.*)

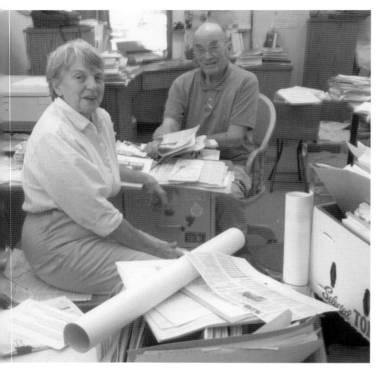

Tom (1923–2004) and Jane Dustin (1929–2003)

Environmentalists Tom and Jane Dustin helped create the Indiana Dunes National Lakeshore and Fox Island County Park. They worked tirelessly to get phosphates banned from detergent in Indiana and protect the Hoosier National Forest from clear-cutting. With James Barrett and Ethyle Bloch, they were among the cofounders of ACRES, Inc. in 1960; today the land trust maintains over 5,000 acres in 90 nature preserves. They also worked to protect the water quality of Cedar Creek, now part of the Indiana Natural, Scenic, and Recreational River System. Tom's favorite expression was "Always appear larger than you are." (Courtesy of the *Journal Gazette*.)

David C. Van Gilder

A former Peace Corps volunteer teacher in Botswana, Van Gilder's love of the outdoors and interest in the environment played into his future as an attorney. After first working with former mayor Ivan Lebamoff, Van Gilder later cofounded the firm of Van Gilder & Trzynka, which now occupies the historic building at the corner of East Wayne and Clay Streets. In addition to his general practice, he specializes in environmental law and has served on the boards of ACRES Land Trust and Fort Wayne Trails. In 2013, he received Indiana's prestigious Randall T. Shepard Pro Bono Publico Award for his work in strengthening the state's volunteer lawyer program. (Courtesy of Faith Van Gilder.)

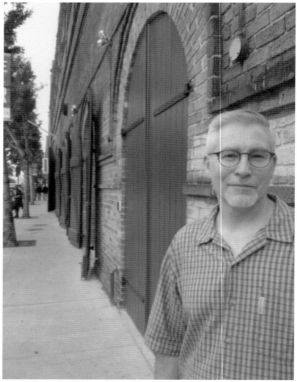

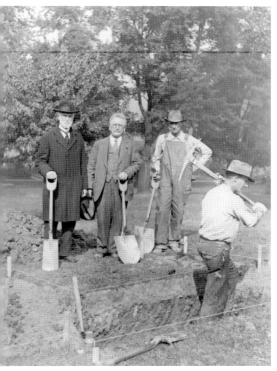

Adolph Jaenicke (1860–1948)

Jaenicke, a third-generation landscape gardener, was trained in Berlin, Germany. In 1893, he came to America to work for Burpee Seed Company; in 1917 he arrived in Fort Wayne and became park superintendent and city forester for 31 years. During that time, 24,000 trees were planted and the park system grew from 110 acres to 39 parks on over 600 acres. Foremost among these were the rose gardens in Lakeside Park, with 23,000 plants of 500 rose varieties, and the Japanese gardens (renamed Jaenicke Gardens in 1941) at Swinney Park, which include specimens seldom found outside Japan. The park also once had a shoji gate, a teahouse, an arched rustic bridge, and a waterfall. He started the Children's Flower Growing Association in 1924, through which seeds were distributed in the city schools and an annual flower show was held. An avid musician, he once sang at the Metropolitan Opera after coming to Fort Wayne. From left to right are David Foster, Adolph Jaenicke, and two unidentified workers. (Left image courtesy of ACFWHS; below image courtesy of the *News-Sentinel.*)

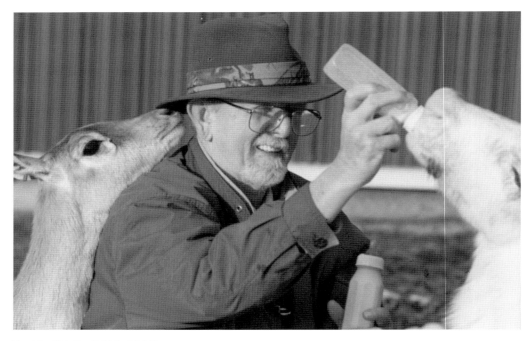

Earl B. Wells (1929–2004)

In 1952, Franke Park gained 54 acres, and from these humble beginnings sprang the Fort Wayne Children's Zoo, which today hosts more than 500,000 guests annually. Hired in 1964, Wells directed and further expanded the zoo and its programs and displays for the next 30 years. The zoo opened on July 3, 1965, with 18 exhibits and 6,000 people attending that first day. The zoo continued to grow, and since its opening, over $32 million has been donated to the zoo for capital projects, and over 20 million visitors have visited the zoo, which now exhibits more than 1,000 animals across 200 species and has 14,000 area households that purchase annual passes. Wells earned numerous accolades during his 30-year tenure and set the stage for the further development that has taken place since his retirement. His replacement was Jim Anderson, who joined the staff as a train driver during a summer break from college in 1976, went on to earn a degree in animal science, and continued working at the zoo for 15 years before becoming its director in 1994. (Above image courtesy of the *Journal Gazette*; below image courtesy of ACPL.)

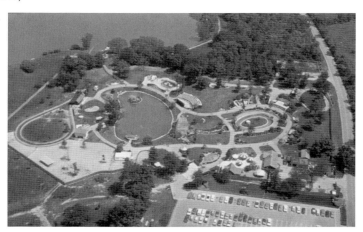

Hana L. Stith

A teacher in Fort Wayne Community Schools for 36 years, community leader and activist Stith cofounded the African/African American Historical Society and its museum on Douglas Street in 2000 and was the curator for over 10 years. She was active with positions in the Metropolitan Human Relations Commission, Fort Wayne Board of Public Safety, and the NAACP. She and her husband, Harold, were instrumental in organizing the city's largest black parade ever—the Juneteenth Parade in 1976 that marched from Lincoln Life's parking lot to Memorial Park for a daylong celebration as part of the local bicentennial events. (Courtesy of the *News-Sentinel.*)

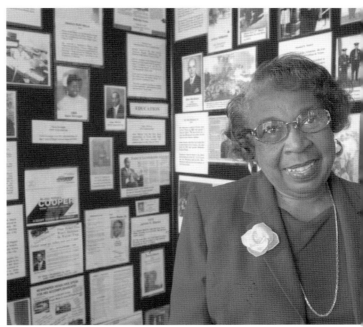

William "Bill" Swiss

For 30 years, Swiss (pictured with coat and tie), has served as president of Anthony Wayne Services (AWS), which serves children and adults with disabilities. At the start of his career, the company had annual revenue of $1 million and employed 40 people in Indiana. The company, now known as Benchmark Human Services, is at the forefront of the deinstitutionalization movement, and today has 3,200 employees who serve 8,500 individuals nationwide and boasts annual revenues of $130 million. In 2007, the company reorganized and formed the nonprofit AWS Foundation, which grants funds to other providers that support people with disabilities. (Courtesy of Benchmark Human Services.)

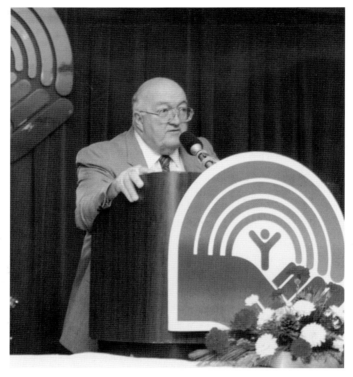

Jerome "Jerry" Henry Sr. (1926–2008)
When Jerry Henry died in November 2008, his family of 17 children, 57 grandchildren, and 36 great-grandchildren, along with the city of Fort Wayne, all lost a patriarch and a true public servant. One of the best-known leaders of a local Catholic family, he and his wife of 59 years, Marganelle, nurtured and raised by example. Their children living locally include the city's mayor, Tom Henry, noted local businessman and investor Jerry Henry Jr., entrepreneurs Tony, Matt, Martin, Kurt, Karl, Louis, and Chris Henry, as well as head of the Allen County SPCA, Jessica Henry.

Henry was a graduate of Most Precious Blood Catholic grade school and Central Catholic High School, where he was senior-class president. After a stint with the Navy, he earned a master's degree from Indiana University. Following a short stay in Michigan, he returned to Fort Wayne, where he was director of social services for the Indiana State Hospital and lived with his family on the school's farm, now the site of Canterbury Green apartments.

He later spent two years as superintendent of the Indiana State Reformatory in Pendleton, earning national recognition as the developer of the state's first work-release program for those involved in nonviolent crimes. He moved the family back home to Fort Wayne in 1968 to begin serving as executive director of Catholic Social Services, where he was an advocate for social change in developing the state's most successful adoption program. A champion of the poor and underserved, he was involved in the implementation of many now well-known community outreach programs, including Big Brothers/Big Sisters, Matthew 25, East Wayne Street Center, and Park Center.

Henry gave generously of his time and talents, serving on numerous local boards, including Fort Wayne Community Schools, United Way, East Wayne Street Center, Family Services of Indiana, Allen County Juvenile Court Foster Care and Mentor Program, University of St. Francis School of Social Work Advisory Committee, Indiana University School of Social Work Advisory Committee, and many other similar organizations. He received many awards throughout his life, including the Sagamore of the Wabash, presented to him by Indiana governor Evan Bayh, and retired in 1991. (Courtesy of Henry family archives.)

Stephen "Steve" Corona The former president and CEO of JobWorks for 30 years, Corona has also been the Fort Wayne Community Schools longest serving board member at more than 34 years of service. Deeply involved in the Hispanic community and on the National Hispanic Council of School Boards board of directors, he is a founder and executive director of Latinos Count, whose purpose is to encourage more local Latino youth to either attend college or get postsecondary training. Corona has given countless hours to the community in addition to the above as a board member of University of St. Francis, Parkview Hospital, Junior Achievement, Leadership Fort Wayne, and the Allen County Courthouse Preservation Trust. (Courtesy of the *News-Sentinel*.)

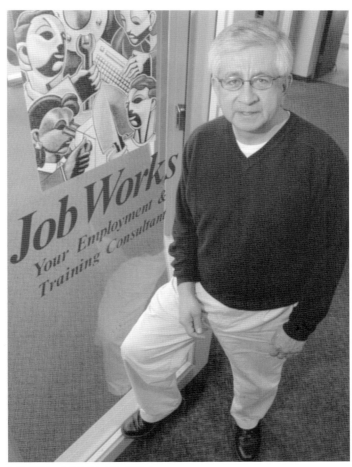

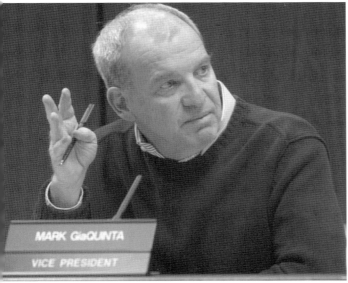

Mark GiaQuinta Mark GiaQuinta served on the Fort Wayne City Council for 16 years. He has also served on a number of other city and county commissions. He is currently president of the board of Fort Wayne Community Schools. By virtue of his extensive experience, he was named to the Indiana Government Efficiency Commission (also known as the Kiernan-Shepard Commission). In all this, he follows in the footsteps of his late father, state representative Ben GiaQuinta. His younger brother Phil is a current member of the Indiana House. (Courtesy of the *News-Sentinel*.)

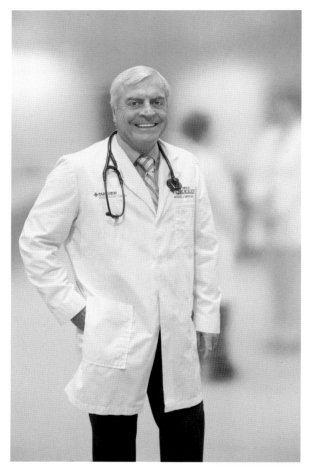

Dr. Michael "Mike" Mirro
Countless patients over the past 30 years may know him as the cardiologist who saved their lives, but the greater medical community recognizes him as the avid researcher who made Fort Wayne a robust cardiac-research center. Mirro is founder and medical director of the Parkview Research Center and has been the principal investigator in over 100 clinical trials testing new medications and devices in the field of cardiology. Widely published and a specialist in cardiac electrophysiology, the philanthropically minded doctor was honored with the 2015 opening of the Mirro Center for Research and Innovation on the Parkview Regional Medical Center campus. (Courtesy of Capture Photography by Neal Bruns.)

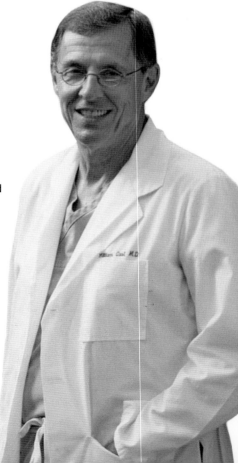

Dr. William "Bill" Cast
Dr. Cast, an otolaryngologist, was part of a small dedicated group of families looking to further challenge their children and provide enrichment activities. They founded Canterbury School in 1977 with 89 students and Cast as its founding president. He later helped start Dupont Hospital, was its founding chairman, and is the chairman of Fort Wayne Medical Surety Company, a physician-owned malpractice insurer. Passionate about bringing technology to the medical profession, he is CEO of NoMoreClipboard, an online patient-controlled personal health-record management system. A published nonfiction author as well, Cast is a nationally recognized physician and entrepreneur and former president of the Indiana University board of trustees. (Courtesy of William Cast.)

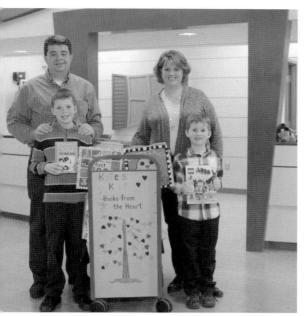

Andrew and Krista Layman
In 2008, after enduring four open-heart surgeries, 18-month-old Katherine "Kate" Layman passed away. Recalling the comfort reading children's books aloud seemed to bring to her, and to themselves, her parents channeled their grief and honored her life by forming Kate's Kart. The Laymans provided the first rolling cart of books to Lutheran Hospital and have since spread to it 16 area hospitals, distributing to children around 2,000 new books each month, reaching the milestone of 100,000 books in 2015. Pictured here are Kate's brothers Seth (left) and Grant (right) and her parents, Andrew and Krista. (Courtesy of Kate's Kart.)

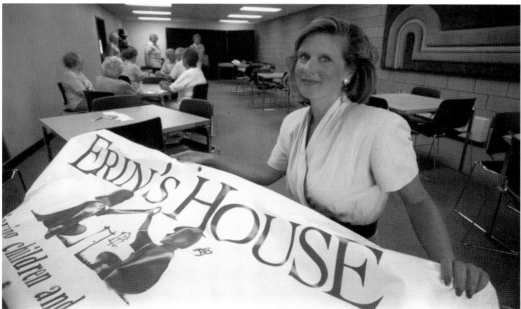

Tracie Martin
In 1989, David and Gail Farragh's daughter Erin died in her sleep. While the parents found adult grief support, the same was not true for their other children. Friend Tracie Martin saw the pain and loneliness that comes with grieving, enlisted fellow Junior League members, and in 1993 founded the organization Erin's House for Grieving Children. Since then it has served over 15,000 children and their families through support groups and a comfortable environment in which to process and discuss their loss. Martin has continued her involvement as a volunteer group facilitator for over 20 years. (Courtesy of the *News-Sentinel.*)

Randy Brown
Lured to Fort Wayne in 1988 by then–coliseum manager Phil Olofson, Brown has been running and transforming the Allen County War Memorial Coliseum for more than 25 years. Completed in 1952, the coliseum under his direction added the exposition center in 1989, in 2002 completed the $34.5-million renovation and expansion of the arena, which included raising the roof 41 feet and 10 inches, and added 24 luxury suites. A new multiuse conference center opens in 2016. It is estimated that the facility's 1,300 events and one million yearly visitors add over $100 million annually to the local economy. (Courtesy of the *News-Sentinel*.)

Sr. Elise Kriss
Sister Elise became president of St. Francis College in 1993. In July 1998, she led the school's transition into the University of St. Francis. During her tenure, the university's offerings have greatly expanded. The original campus, bought from the family of John Bass in 1944, reflects this with 10 new buildings, as well as the restored Brookside mansion, now offices. The Shields Athletic Complex is planned west of the stadium. A downtown campus is in the works with the purchase of the Scottish Rite Auditorium and the former chamber of commerce building to house theater and business programs. (Courtesy of the *Journal Gazette*.)

CHAPTER THREE

Entrepreneurs and Business Professionals

Entrepreneurship can be either a matter of creating something completely new or perhaps more often creating the local version of an institution or phenomenon that exists in society at large. One expression of Fort Wayne's assimilation into a mass culture is the extent to which both have happened here. The city has been the stage on which the process of taking some entirely new idea or gadget and creating an industry or an institution around it has taken place. In some cases, this has created institutions with great longevity. Whole sectors of the local economy have been spawned as the participants in the original enterprise go off to start their own firms and work out their own versions of the original success. In Fort Wayne, this has successively been the case in the pump, magnet wire, and electronics industries. In others, the pace of technological or cultural change that a development spurred has ensured that innovators would go elsewhere to find the resources needed to fully realize their dreams. In some cases, a local innovation has attracted competitors based elsewhere who have outdone the local entrepreneurs, or those business founders have realized that economic conditions dictate that they must leave in order to continue to flourish. This last is the great economic conundrum of the local economy at present, as ways are sought to compete in a globalized economy.

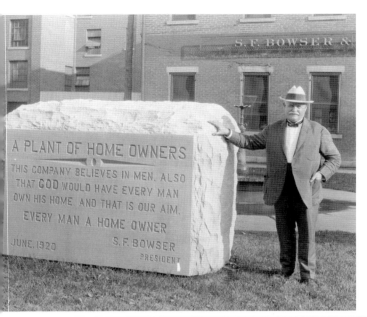

Sylvanus Bowser (1854–1938)
In 1885, Bowser invented the first kerosene-dispensing pump. When gasoline became the fuel for internal-combustion engines, Bowser introduced a model that would pump gas from a 50-gallon tank mounted on the pump in a wooden cabinet. That was dubbed a "filling station" by Bowser employee Jake Gumper. Fort Wayne became a center for gas-pump manufacture with the addition of the Tokheim and Wayne companies. Bowser was a strong believer in home ownership and started a saving and loan for his employees. (Courtesy of ACFWHS.)

Emil Deister (1872–1961)
After emigrating from Germany in 1878, Deister worked on the family farm near Woodburn, Indiana. He became stable boy at John Bass's estate, rising rapidly to staff manager. Later a lathe operator at Bass Foundry, he studied ore separation and patented his own equipment. He founded Deister Concentrator in 1906 and Deister Machine Company in 1912. The industry innovator, Deister Machine produces feeding, scalping, and vibrating screening equipment for aggregate and mining applications in all 50 states and internationally. In continuous operation since its incorporation, the company is still family owned by Irwin Deister Jr. and E. Mark Deister. (Courtesy of Deister Machine.)

W. Clyde Quimby (1880–1935)

After opening a dozen theaters in Ohio and Pennsylvania, Quimby came to Fort Wayne in 1914 and leased the Jefferson (present site of the Grand Wayne Center). In 1928, he leased the new Fox Theater and named it the Emboyd, after his mother, Emma "Em" Boyd; it later became the Embassy. In 1930, he leased the new Paramount Theater on Wayne Street. For most of the 1920s he also operated the Palace Theater. Quimby was also a vice president of both the Dime Trust & Savings Bank and Randall Investment Company. Quimby's widow, Helen, continued the business as president of Quimby Enterprises, which owned and operated the Embassy Theater and the Quimby Auditorium (the Scottish Rite Auditorium, which she leased in 1945 and owned until selling it to the Scottish Rite lodge in 1953). She was president of Harrison Theater & Realty Company, which owned and operated both the Paramount and the last great movie palace built in the city, the Clyde Theater, built on a suburban site along Bluffton Road in 1950. The Quimby Village Shopping Center where the Clyde stands was built by Helen Quimby as president of the Helen M. Quimby Realty Company. (Above image courtesy of the Embassy Theatre Foundation; below image courtesy of ACFWHS.)

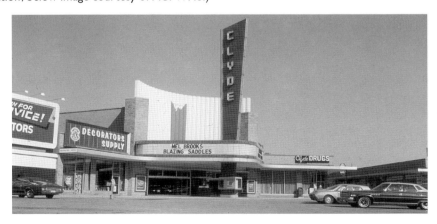

Louis Curdes (1863–1934)

Emigrating from Germany in 1879, Curdes found work as a tuner at the Packard Organ Company; 12 years later, he became a successful realtor representing the Tri-State Building and Loan in developing Williams Addition. In 1903, he worked with the Williams heirs to develop the city's first addition with protective covenants. In 1906, Curdes platted the Forest Park Addition north of downtown, a third of which was Forest Park Boulevard, 75 large lots available by invitation along a street with a landscaped median. Curdes can be justly regarded as the pioneer of modern real estate development in Fort Wayne. (Courtesy of ACFWHS.)

Dale "Mr. Mac" McMillen Sr. (1880–1971)

In 1934, McMillen formed Central Soya in an old sugar beet mill in Decatur. Specializing in soya-oil extraction and producing soya bean meal, McMillen sold his Master Mix brand of animal-feed supplements around the world. After acquiring other companies in the field, his was the first company to ship the product in its own covered hopper cars and own barges on the Ohio and Mississippi Rivers. Joined by sons Harold and Dale Jr., the company went public in 1960. Philanthropically minded, McMillen gave the city McMillen Park and founded the nationally known Wildcat Baseball program. (Courtesy of ACFWHS.)

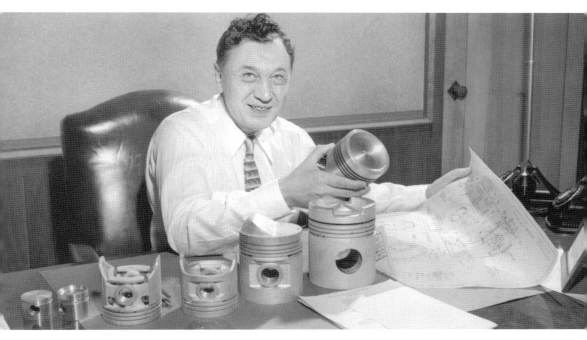

Fred Zollner (1901–1982)

Zollner Corporation located in Fort Wayne to be close to automobile and truck centers. When Fred took over the company in 1952, it was producing 70 percent of the heavy-duty aluminum pistons in the world. Zollner pioneered piston designs using bimetallic alloys of aluminum and iron. He had a lifelong interest in sports, especially basketball. The Zollner Pistons won four consecutive championships. By 1949, their league had evolved into the National Basketball Association. Zollner moved the team to Detroit in 1957 and sold it in 1974. His Pistons softball team lost only 189 of 1,253 games and won seven championships. (Courtesy of the *News-Sentinel*.)

Frank M. Freimann (1905–1968)

An immigrant from Hungary, in 1929, inventor and businessman Freimann formed the Electro Acoustic Products Co. in Chicago and after merging it with Magnavox moved operations to Fort Wayne in 1938. Freimann became president of Magnavox in 1950, when sales were just $32 million and by his death in 1968 had grown the company to $400 million in sales. In his charitable trust were left funds that were later used for the development of Freimann Square in 1971 and Foellinger-Freimann Botanical Conservatory in 1983. (Courtesy of ACFWHS.)

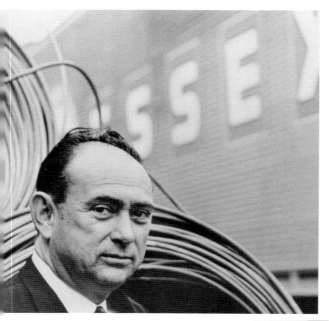

Walter F. Probst (1915–1994)
With a University of Michigan law degree, Probst joined Detroit's Essex Wire in 1942, became its president in 1959, and moved the company's corporate headquarters to Fort Wayne in 1960. Taking Essex public in 1965, he directed a long string of acquisitions leading to 113 plants in 17 states and five countries, becoming the company's chairman and CEO in 1966. Under his direction, with little or no publicity, the company gave back to many of the communities in which it had facilities, in many cases by underwriting the development of cardiac-care units at local hospitals. (Courtesy of ACFWHS.)

Victor Rea (1889–1954)
When George Jacobs moved to Fort Wayne in 1910 and formed the Dudlo Company, with him came friend Victor Rea, who had known Jacobs back in their Dudley, Massachusetts, days. After Dudlo was merged with General Cable in 1930, Rea would become the division manager, with responsibility for more than 7,000 employees. Leaving in 1933 to form Rea Magnet Wire, he orchestrated numerous company expansions and innovations to the wire-drawing industry. After his sudden death, sons Sam and David, who were already working at the company, took over operations, continuing the company's growth before selling it to ALCOA in 1960. (Courtesy of Rea Magnet Wire.)

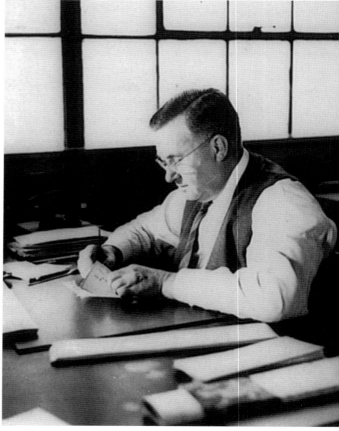

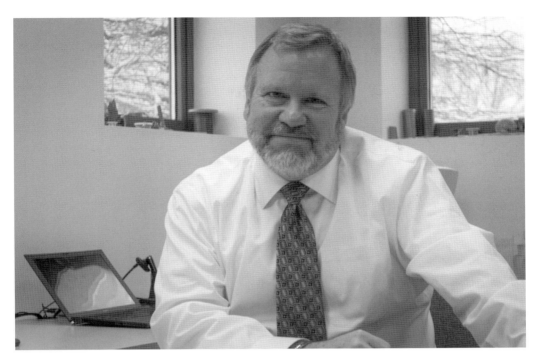

Scott A. Glaze

Scott's father, Ardelle Glaze, a former research scientist, established the wire-drawing company Fort Wayne Metals in 1946. Specializing in making wire for medical applications, Scott became company president in 1985, a time when the company had just 30 employees. The more than 750 employees today make wire for orthopedics, orthodontics, catheterization, pacemaker leads, and other products. The philanthropically minded Glaze, along with his wife, Melissa, have quietly become leaders in buying, renovating, and repurposing downtown buildings as well as supporting numerous other civic projects and nonprofit organizations. (Courtesy of Fort Wayne Metals.)

Ove W. Jorgensen (1915–2005)

After a stint with the Studebaker-Packard company, Jorgensen joined Essex Wire in 1955 as vice president of finance. Jorgensen and Pres. Walter Probst packaged the company's 13 divisions and took Essex public on the New York Stock Exchange in 1964, setting the stage for the amazing growth that the company enjoyed though the 1970s. With sales topping $1 billion, he and then-president Paul O'Malley managed the 1976 merger of Essex with United Aircraft (United Technologies). Jorgensen gave back to the community in many ways, including serving on the local Junior Achievement board for nearly 40 years and founding the Jorgensen Family YMCA. (Courtesy of Jay and Jane Jorgensen.)

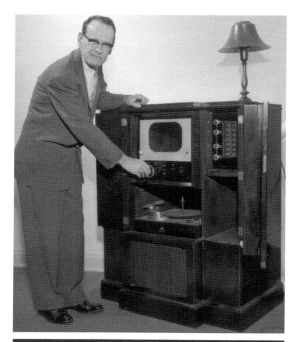

Philo T. Farnsworth (1906–1971)

When he was 15, Farnsworth saw plowed furrows in a field and wondered if an electronic beam passing back and forth could be used to form an electronic image. He spent the rest of his life developing, patenting, and licensing television. In 1927, he transmitted his first image. In 1939, Farnsworth Television and Radio Company bought the Capehart Company of Fort Wayne to manufacture radios and televisions. After a long patent battle with RCA, he was vindicated. In 1949, his company became part of International Telephone & Telegraph. Farnsworth held 165 patents. (Courtesy of the *News-Sentinel.*)

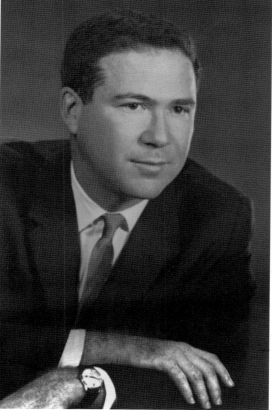

Edward A. White

Edward White's story sounds like a Silicon Valley start-up; in 1951, he started manufacturing small gear assemblies in a garage, primarily for aeronautic applications. The business grew rapidly, erecting the Bowmar Instrument Company plant on Bluffton Road in 1957. When a Canadian subsidiary developed the LED (light-emitting diode) display, White unsuccessfully tried to interest computer firms in it. To demonstrate its use, Bowmar introduced the first hand-held electronic calculator, the Bowmar Brain, in 1971; it sold for $240. Sales jumped to $78 million in 1974, but this also brought competition into the field that nearly bankrupted the company, which returned to its former focus. (Courtesy of the *Journal Gazette.*)

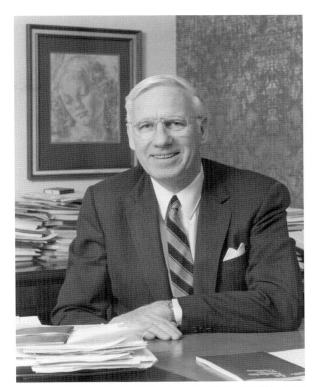

Richard "Dick" Doermer (1922–2010)

A graduate of South Side High School, Notre Dame, and Cornell University Law School, Doermer became a leading local community leader, businessman, and philanthropist. His career started with the old Dime Bank, which he later renamed Indiana Bank & Trust. He merged Indiana Bank with Peoples Trust, which became the resulting Summit Bank in 1983. Summit Bank became an affiliate of NBD Bancorp in 1992, and he retired shortly thereafter, in 1993. He and his wife's foundation gave the funds for the Doermer Family Health Science Building at University of St. Francis, and he has generously supported many other local organizations. (Courtesy of the *News-Sentinel*.)

Jackson "Jack" Lehman (1931–2013)

With an MBA from IU, Lehman started at Fort Wayne National Bank (now PNC) in 1956, worked his way up the ranks, and became president in 1987 and CEO in 1991. Spearheading many successful acquisitions for the bank, his most lasting gift to the city is likely in guiding donors Mary Tower English, Louise Bonter, and Mary Elizabeth Mitchell in the formation of the English Bonter Mitchell Foundation. Established as a tribute to Lincoln Life's Dr. Calvin English, the foundation distributes millions to civic projects and nonprofits in the area each year. (Courtesy of the *Journal Gazette*.)

G. Irving Latz (1888–1947)

In 1896, Sam Wolf and Myron Dessauer started what was then one of many dry-goods stores downtown. By 1908, the store occupied a large building on Berry Street; in 1917 the partners built a larger store at the northeast corner of Washington and Calhoun Streets. They hired Latz that same year and made him general manager in 1919. Shortly after that, the partners sold the store to Latz. Through progressive policies toward both his customers and employees, Latz became the premier retailer in Fort Wayne. The business was carried on by his two sons William and G. Irving Latz II. The store moved to a larger building (now Citizens Square) in 1959; in 1962 the 1919 building burned. In 1969, Wolf & Dessauer was sold to L.S. Ayres. That same year, W&D had closed a branch store that had been in Huntington since 1952 and opened a store at Southtown Mall. The lighted Santa Claus and reindeer and Christmas wreath that debuted on the outside of the store in 1937 have been restored and displayed on the PNC Bank (former Fort Wayne National Bank) and AEP Building (former Summit Square) as a holiday tradition downtown since 1980. (Above image courtesy of Gil and Sara Latz; below image courtesy of ACPL.)

Christmas
at
WOLF & DESSAUER
FORT WAYNE 2, IND.

Edward "Ed" and Joseph "Joe" Dahm In 1948, and with only 17 automatic carwashes in the whole United States, Joe (right) opened the 18th—Mike's Minit Man Carwash on Calhoun Street. A few years later, his brother Ed (left) joined the business, and together with their sons, they built one of the country's largest carwash chains, with 41 locations. They washed their 100 millionth vehicle in 2012. Today, Joe's sons Bill and Mike run the company and have since reorganized it into two independent businesses. Mike's company retained the Mike's Carwash name and is headquartered in Cincinnati, Ohio, with a satellite office in Fort Wayne; Bill's company, Crew Carwash, is headquartered in Indianapolis. (Courtesy of Mike's Carwash.)

Walter McComb Jr.
David O. McComb, superintendent of Allen County Public Schools for 24 years, opened a funeral home on East Lewis Street in 1925. In 1927, the funeral home was relocated to its current Lakeside location. In 1940, he instituted the only free emergency ambulance service in the area. The third and fourth generation, Walter Jr. and his sons Doug and Dave (pictured left to right), have made the eight family-owned funeral homes the second largest group in the state. Under Walter's sons' leadership, the philanthropic-minded business now includes a state-of-the-art crematory, Riverview Cemetery, and the Birkmeier Monument. (Courtesy of D.O. McComb & Sons.)

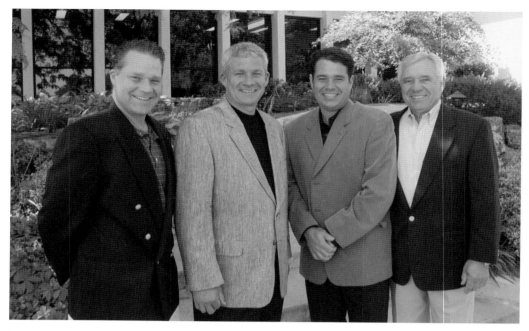

Jon Lassus Sr.
In 1925, August Lassus built his first gas station, eventually turning it over to his three sons Elmer, August Jr., and William, who continued to expand the company. In 1960, Elmer's son Jon joined the company. Under his leadership, and with his sons, the company is recognized as one of the area's largest suppliers of gasoline, with more than 30 locations in Indiana and Ohio, and for the ubiquitous Handy Dandy convenience stores and growing Elmo's Pizza and Sub restaurant chain. Pictured here from left to right are Greg, Jon R., Todd, and Jon Lassus Sr. (Courtesy of Lassus Handy Dandy.)

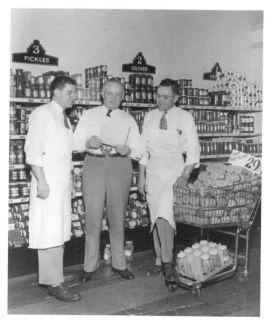

William W. Rogers (1886–1970)
After stints with Hoosier Stores and Kroger Company, Bill Rogers opened his own grocery store in 1944 at Jefferson and Webster Streets at a time when the city already had 350 neighborhood markets. Joined by sons John and Harry, the company grew to 15 stores and a workforce of over 1,300. Opening various formats, they gave the city Rogers Markets, City Market, Cub Foods, Food Express, and Hoosier Foods. Expanding into shopping centers, the company sold the store operations to SuperValu, Inc. in 1995 and retained the extensive real-estate holdings. Pictured here from left to right are Harry, W.W., and John Rogers. (Courtesy of Rogers Markets, Inc.)

Donald "Don" Keltsch (1924–1992)

Don joined his father in the pharmacy business in 1948 at his store at the corner of Wells and Third Streets, and in 1950, his brother Maurice, also a pharmacist, joined the business. Forming the company Keltsch Bros., Inc., in 1960, they opened a second drugstore on West State Boulevard and continued to expand to 18 modern stores, two clinics, and a gift store scattered across six Northeast Indiana communities. Don's son Richard later became CEO and continued to build the company until selling it to the Scott's Food Stores division of SuperValu in 1998. (Courtesy of Karen Keltsch Butler.)

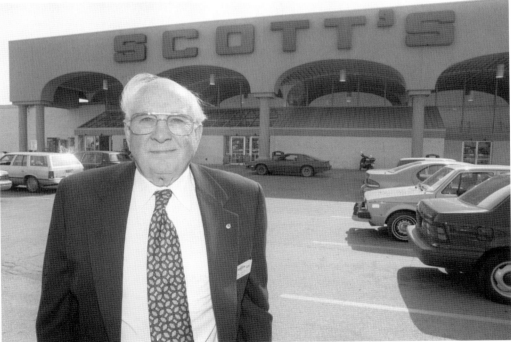

Donald "Don" Scott (1917–2008)

After working for Marsh Supermarkets for 13 years, Don opened his own store at Fairfield Avenue and Taylor Street in 1954. He merged his stores with his friend and later vice president Bill Reitz's operations in 1979. The two men built the Scott's chain together for 45 years. After Don's wife died of cancer in 1978, he started the annual Cancer Day fundraiser, which continues to this day. Operating under the Scott's name, the 18-store chain was sold in 1991 to SuperValu, Inc., and in 2007 was acquired by Kroger Company. (Courtesy of the *Journal Gazette*.)

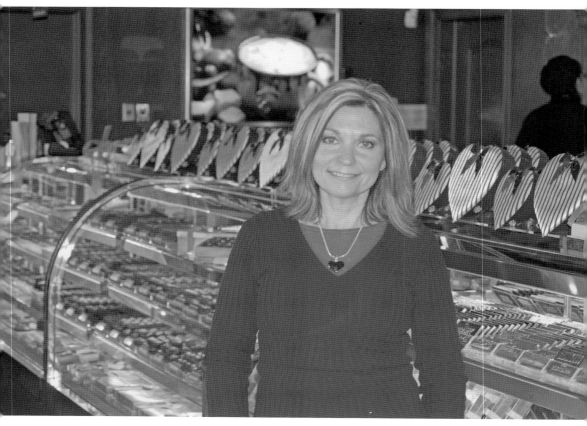

Cathy Brand-Beere
Living above the family cake-decorating supply business gave Cathy Brand-Beere the opportunity to learn the art of chocolate making at the tender age of eight. Since opening a small retail shop in the front room of her family's business in 1987, her DeBrand Fine Chocolates creations are now made in her and husband Tim's modern 30,000-square-foot plant on Auburn Road and available through their three retail stores, via their glossy catalog, the Internet, and various upscale stores nationally and in Kuwait. With her husband, she directs 80-plus employees and ships the luxurious and delightful confections around the globe. (Courtesy of the *News-Sentinel*.)

Donald "Don" Ellis (1925–1978)

After working as a teenager at downtown's Bon Ton Bakery, with his father's help, Don would go on to found Ellison Bakery in the family garage in 1945. Joined by brothers William and Richard, the company became an Archway brand licensee in 1949. Ellison underwent repeated expansions and in 1964 moved into a modern 120,000-square-foot Ferguson Road facility, enabling it to churn out over 1.8 million cookies a day. Discontinuing the Archway franchise in 1997, the company, still family-owned, then grew its private label, food service, crunch toppings, and ice-cream inclusion items, as well as its own brand of cookies. (Courtesy of Ellison Bakery, Inc.)

Charles "Charlie" Seyfert (1911–1984)

Charles Seyfert of Lebanon, Pennsylvania, stopped in Fort Wayne on his way back from the Chicago World's Fair in 1934. The result of this visit was his opening a small potato-chip operation on East Wallace Street, and as the only employee, Seyfert washed, peeled, sliced, fried, and packaged the chips that he sold to local taverns. Achieving great success, in 1965, Seyfert built a three-acre under-roof state-of-the-art snack-foods manufacturing plant at Lima Road and Interstate 69 that supplied markets in three states. Seyfert sold to Borden, Inc. in 1982, and now Troyer Foods owns the brand. (Courtesy of Maria Seyfert.)

Francis "Frank" Gardner (1911–1983)

In 1935, Gardner's Drive-In opened at the northwest corner of West Jefferson and Webster Streets, selling a steak hamburger for 10¢. Frank, a South Side graduate, operated the hugely successful local landmark with help from his parents and wife, Ilah (pictured), until selling it in 1955. In 1957, the Gardners founded Char-King restaurants, featuring the Charky hamburger steak and Henny Penny fried chicken. Frank's final restaurant would be Char-King's Farm Fare Cafeteria at the corner of Coliseum Boulevard and Parnell Avenue. Gardner sold Char-King's to Azar's in 1971, and the Coliseum Boulevard site became home to Azar's Captain Alexander's Moonraker. (Courtesy of ACFWHS.)

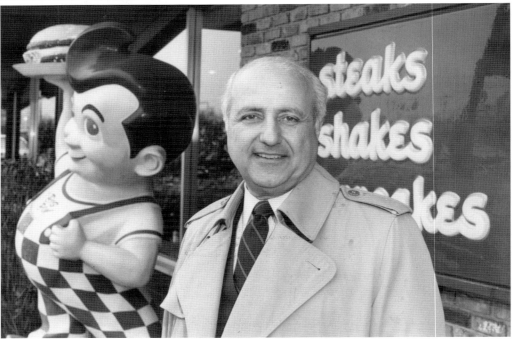

Alexander "Alex" Azar

Alex and his brother David originally had a grocery on Calhoun Street, but in 1954 they opened their first restaurant as Big Boy franchisees. Three decades later, the business had grown to be worth more than $40 million, with stores in Indiana and Colorado as well as Captain Alexander's Moonraker and Charky's restaurants in Fort Wayne and the Back 40 Junction in Decatur. In 1967, they also obtained a Marriott franchise and developed hotels in Fort Wayne and Grand Rapids, Michigan. At its peak, Azar, Inc. employed about 2,000 people. Today, the company, now owned by Alex's son George, still operates the Waynedale Big Boy and the Back 40 Junction, but it is largely a real-estate investment and management enterprise. (Courtesy of the *News-Sentinel*.)

Dave Thomas (1932–2002)

When he was 15, Dave Thomas came to Fort Wayne, lived at the YMCA while attending Central High School and working at the Hobby House Restaurant as a busboy. In 1962, Thomas went to Columbus, Ohio, to improve the operation of four restaurants there. After doing so, Thomas opened the first Wendy's restaurant, a move many considered too risky because of competition with McDonald's. Wendy's grew to 6,000 stores worldwide by 2002. (Courtesy of the *News-Sentinel*.)

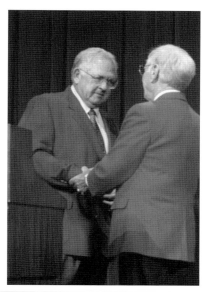

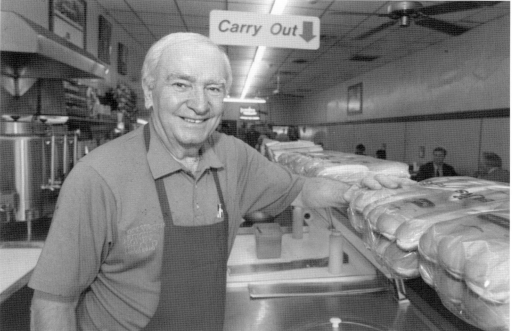

Russell "Russ" Choka (1923–2011)

A fixture at Fort Wayne's Famous Coney Island, Choka, the son of Macedonian immigrants, served the Summit City's full spectrum of economic and social "regulars" for over 50 years. Russ took over from his ailing father-in-law, Vasil Eshcoff, in 1958 and worked behind the counter not only with other family members but with young employees who considered him a father figure, admiring and emulating his work ethic. Choka continued to run the business, chopping onions and serving the city's famous hotdogs on steamed buns until the end. Today, Jimmy Todoran and Russ's daughter Kathy Choka are co-owners, still offering up Coneys in the family tradition. (Courtesy of the *Journal Gazette*.)

Donald "Don" Hall (1915–1972)

Though the Hall family had a successful meat market on South Calhoun Street, Don Hall became concerned about the survival of the family business as supermarkets proliferated after World War II. In 1946, he started a restaurant in the Quimby Village Shopping Center; three years later, he capitalized on the popularity of drive-ins by adding carhops, as well as a pick-up window. A second restaurant opened in the former gas works on Superior Street soon thereafter. Through the 1960s and 1970s, Hall's expanded, growing into a dozen restaurants and a hotel in Fort Wayne and one restaurant in Indianapolis. With the exception of the Takaoka of Japan Steakhouse at the Gas House, the restaurants still serve the family fare that made them a local institution. Hall's remains a family business headed by Don's son Bud (Don Jr.) and his brothers. Pictured left to right below are brothers Jeff, Sam, Scott, and Bud. (Right image courtesy of Hall's Restaurants; below image courtesy of the News-Sentinel.)

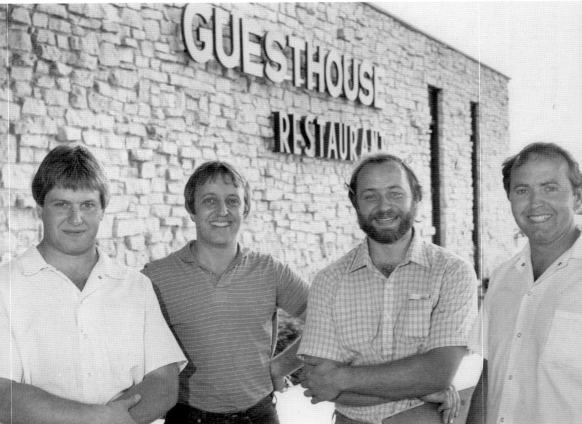

Richard "Dick" Freeland (1937 –2013)
In his hometown of Des Moines, Iowa, Freeland took a part-time job at a local Pizza Hut for $1.25 per hour. Noticing open franchise area in Indiana, he moved to Fort Wayne in 1972 and opened his first location on East State Boulevard, with himself as manager, wife Deanna as waitress and bookkeeper, and their children as table bussers and pizza makers. Fast forward to 2013, and with hard work, empowered employees, and smart management the philanthropic Freelands enjoyed the American Dream, living in a beautiful home, known locally as Freeland Castle, and operating nearly 50 Pizza Hut and KFC locations in Indiana and Ohio. (Courtesy of the *News-Sentinel*.)

John N. Spillson (1921–1995)
Spillson grew up around the restaurant business; his father owned the Berghoff Gardens restaurant on Harrison Street. In 1961, he transformed his Big John's Pizza into Café Johnell, one of the city's most elegant restaurants, with red velvet upholstery, linen tablecloths, and framed paintings. A touch of local history was provided by the entry doors, which originally graced the Rockhill Mansion. His daughter Nike studied classical cuisine in France, and son Jon served as wine master. Café Johnell became perhaps the most award-winning restaurant in Fort Wayne; for more than 25 years it received a four-star rating in national restaurant guides. (Courtesy of ACPL.)

William "Bill" Humphries

Humphries worked through high school as a busboy at the Moonraker and Cork n' Cleaver. After college, he happened upon a sub shop in Florida with a line of customers out the door, contacted the company, bought a franchise, and opened the city's first Subway restaurant in 1983 across from Northcrest Shopping Center. He later became a development agent for the franchise and today oversees 750 Subway locations in Indiana and Ohio. In 2001, Humphries launched his upscale Eddie Merlot's steakhouse restaurant, building his first unit at Jefferson Pointe. The growing chain now also has locations in Indianapolis, Cincinnati and Columbus, Ohio, Louisville, Kentucky, Chicago (three locations), Detroit, Pittsburgh, and Denver, Colorado. (Courtesy of Eddie Merlot's.)

Richard "Dick" Waterfield

Joining his father's mortgage company in 1969, Waterfield oversaw the company's growth to 40 offices in 15 states, employing 2,300 people prior to divesting it and its $3.7-billion Indianapolis S&L in 2006. He now heads an investment management company, Waterfield Capital, LLC. Active in civic activities, he was a cofounder of the Community Development Corporation, Fort Wayne Sports Corp., and Downtown Improvement District. His family's Waterfield Foundation was instrumental in establishing the Courthouse Green and scholarships and housing at IPFW. Former president of the Canterbury School Foundation, he serves as its investment committee chair as well as on the Riley Hospital Foundation and Fort Wayne Park Foundation boards. (Courtesy of Waterfield Capital.)

Laurence E. Tippmann (1909–1984)

Born in Connellsville, Pennsylvania, in 1909, Laurence moved with his parents, brothers, and sister to Gary, Indiana, in the early 1920s after Prohibition ultimately caused the demise of the family brewery. Laurence's father, Joseph Tippmann, eventually started a refrigeration-repair business in Gary, and Laurence became his assistant.

Laurence met his future wife, Mary Loretta Cross, and they were married in 1931. Continuing with his trade in Gary until 1935, Laurence and Mary and their three children moved to Fort Wayne, where Laurence eventually went to work for Burge Ice Machine Co. as a regional sales representative. With their family growing to seven children, Laurence and Mary bought a small house on East State Street with five acres of land adjoining 160 acres of woods, which they felt would be a great place to raise children. It was here that they raised their 16 children, all of whom attended St. Jude Grade School and Central Catholic High School. In 1949, with the help of his older children, Laurence founded Tippmann Engineering Inc. in a building they erected next to their home. Success was elusive but eventually arrived with the invention and patent of the Tippmann Plate Ice Maker in 1957, which they manufactured for two years before selling the patent rights to Turbo Refrigerating Co. in Chicago (renamed the Turbo Ice Maker). These machines were widely used throughout the world and are still manufactured today under the same patent design. For the roughly 30 years that Tippmann Engineering existed, it would become the training ground for almost all the Tippmann children, where they learned firsthand the mechanics of refrigeration, the art of sales, and the ethics of business. It was because of this training that the Tippmann children would enter the business world and become some of the most successful entrepreneurs in the community, founding nearly 100 diverse businesses and patenting over 200 products they developed. The family has set up a number of foundations, including the Mary Cross Tippmann Foundation, and gives generously, mostly in a quiet fashion, to numerous religious education and pro-life initiatives and supports efforts to relieve the suffering of the poor and needy. (Courtesy of John V. Tippmann Sr. and the Tippmann family.)

Leonard Rifkin (1931–2008)

Leonard Rifkin was born in New York City, the son of Russian immigrants. When his father, Irving, bought a small scrapyard on North Clinton Street in 1943, the family moved to Fort Wayne. A musical prodigy, Leonard played violin in the philharmonic at age 13. A graduate of North Side High School and Indiana University, he joined his father in 1956. Under his leadership, OmniSource became the largest scrap processor in North America and the first local private enterprise to sell for over $1 billion. An original founder of both Steel Dynamics and Tower Bank, he was recognized as a true entrepreneur and community leader. (Courtesy of the *Journal Gazette*.)

James "Jim" Shields

After reading a book about the stock market, in 1946, Shields walked into the Fort Wayne Merrill Lynch office and asked how to get a job there. He started by marking the chalkboard with stock quotes and went on to spend 28 years with the company. In 1983, he took a chance on emerging technology to heat and cool homes with ground-source heat pumps. Starting with just two other employees, the company, WaterFurnace International, flourished and sold HVAC units worldwide and employed 278 people in Fort Wayne. In 2014, the company was sold to a Swedish firm for $350 million. (Courtesy of Tim Shields.)

Barbara Bradley Baekgaard and Patricia Miller

Beginning as Wildwood Park neighbors who in 1974 started a wallpapering business called Up Your Wall, the Baekgaard (left) and Miller (right) partnership evolved into designing and making the first Vera Bradley handbag in 1982. Miller recounts how the two women were coming home from a Florida vacation where they had visited Barb's mother, Vera Bradley, and while in the Atlanta airport noticed travelers carrying canvas bags. Feeling they could design and make something more feminine looking and attractive to carry, they came home and designed and made a prototype bag. They each contributed $250 to buy fabrics, and the company began working out of Miller's garage. Mentored for years by Fort Wayne's chapter of the Service Corps of Retired Executives (SCORE), the copresidents overcame one obstacle and business problem after another as the company, distribution, and product line expanded with a variety of quilted cotton rolling luggage, travel bags, duffels, and other branded items. Spreading out into licensed items grew the product line further with bedding, fine rugs, pillows, lamps, dinnerware, furniture, note pads, pen and pencil sets, iPhone covers, scarves, and eyewear. Now the owner of over 650 patented designs, Vera Bradley began moving some of its operations from Interstate Industrial Park into its new facility at I-69 and Lafayette Center Road in 2007. Since further expanded, it measures over 450,000 square feet. In 2010, the company was taken public and trades on the NASDAQ as VRA. The product line is now handled by over 3,500 retailers worldwide, and 2014 sales exceeded $500 million. In 2014, these sales came in part from the company-owned 84 full-price retail stores and 15 outlet stores, as well as 14 store-within-a-store department store locations in Japan, 3,100 specialty retailers in the United States, selected department stores, including Dillard's and Von Maur, e-commerce, and other channels. Vera Bradley's famous annual outlet sale held at the Allen County War Memorial Coliseum attracted 68,000 attendees in 2013. In 1998, they established the Vera Bradley Foundation for Breast Cancer Research, which has since raised and distributed over $23 million. (Courtesy of the *News Sentinel*.)

Charles "Chuck" Surack

Surack, who played saxophone in the Wayne High School marching band, founded Sweetwater Sound as a recording studio in 1979. In the early 1980s, he began selling keyboards, then became a retailer of thousands of items in the sound, music, and recording industry. The company and its over 800 employees enjoy a state-of-the-art and amenities-filled headquarters on US 30 West. Additionally, Surack owns 10 businesses, including SweetCars, Sweet Aviation, and Longe Optical. He is a frequent speaker and mentor on issues from entrepreneurship to quality customer service and the pursuit of excellence. Involved in various other enterprises and community organizations, he and his wife, Lisa, are among the area's leading philanthropists. (Courtesy of Capture Photography by Neal Bruns.)

Keith E. Busse

A North Side High School graduate with a degree in finance from University of Saint Francis and an MBA from IPFW, Busse spent 21 years with steelmaker Nucor. In 1993, Busse and coworkers Mark Millett and Dick Teets struck off on their own and founded Steel Dynamics (SDI). In 1996, SDI was the smallest of 60 companies in the country making hot metal; now, they are the fourth largest, have 7,500 employees nationwide, and surpass $10 billion in annual sales. Busse, now retired from the day-to-day running of SDI, generously supports local education and nonprofit organizations and is involved in a variety of other business ventures. (Courtesy of the *Journal Gazette*.)

Tom Borne

Tom Borne is president of Asher Agency, an award-winning advertising, marketing, and public relations firm on West Wayne Street. When his brother Tim Borne founded Asher in 1974, it had one employee servicing one account; by 2014 there were 60 employees in eight offices. Asher is the No. 1 advertising agency for Subway Restaurants and has Indiana's largest media-buying department, in addition to doing pro bono work for the Embassy Theatre and Fort Wayne Community Schools Foundation. Tom received the Sagamore of the Wabash award from Gov. Evan Bayh in 1997 and the Silver Award for Lifetime Achievement from Fort Wayne Advertising Federation in 2014. (Courtesy of the Asher Agency.)

Donald "Don" Wood

Don Wood, a former toolmaker by trade and salesman by attitude, saw a need and became an entrepreneur at the age of 58 when he rented 2,000 square feet of space in the Fort Wayne Enterprise Center. With a burning desire, small product offering, a few employees, and an eight-page black-and-white catalog, Don formed 80/20, Inc., manufacturing and selling the Industrial Erector Set, a T-slot aluminum building system. Today, his company is located on a 300,000-square-foot campus off US 30 West, employing more than 400 people and providing over 7,500 products in its 1,248-page catalog. (Courtesy of 80/20, Inc.)

Arnold Gerberding (1900–1977)

In 1945, Arnold Gerberding's enthusiastic vision brought seven independent hardware store owners to a warehouse on Hayden Street to form a dealer-owned buying cooperative called Hardware Wholesalers, Inc. (HWI). Locating their offices in downtown Fort Wayne, by 1948 they had purchased 10 acres of land on Nelson Road near New Haven and constructed their first facility. Having tested and rolled out the Do-It-Best store concept in the 1980s and its retail signage and identification program in 1996, HWI officially changed its name to Do it Best Corp. in 1998. In addition to their world headquarters here in Fort Wayne, they now have massive state-of-the-art distribution centers in Missouri, Ohio, Illinois, New York, South Carolina, Texas, Oregon, and Nevada, which stock over 67,000 different items from hammers and nails to beach umbrellas. The company has grown to 3,800 member-owned hardware stores, home centers, lumberyards, and industrial/commercial suppliers throughout the United States and 53 other countries, with annual sales reaching $3 billion. Gerberding's vision has continued to thrive under the servant leadership of industry innovators and committed civic leaders Don Wolf (1967–1992), Mike McClelland (1992–2002), and Bob Taylor (2002–present). (Both images courtesy of Do it Best Corp.)

R. Bruce Dye
Dye founded Heritage Food Service Equipment, where he employed nearly 400 people and had annual sales of $100 million before divesting the company in 2011. As owner of Hotel Fitness, a national supplier of turnkey fitness rooms for the hotel industry and other facilities, he has sponsored and supported high-caliber golf in Fort Wayne, including the Junior PGA Championship, Mad Anthony's Charity Classic, and Hotel Fitness Championship. Philanthropically inclined, Dye supports dozens of local charities, the new football training center at University of Saint Francis, and Mad Anthony's Hope House at Lutheran Hospital, as well as the Three Rivers Festival. (Courtesy of the *Journal Gazette*.)

Kenneth "Ken" Maxfield (1924–2013)
Maxfield attended Leo High School, earned a law degree from DePaul University, and eventually became the well-respected president of North American Van Lines (now SIRVA). When North American was sold to PepsiCo in 1984, Maxfield successfully fought to keep the headquarters in Fort Wayne. After retiring in 1989, he spent countless hours serving in community leadership roles for local civic and nonprofit organizations. He was joined at North American by future community leaders Joseph Ruffolo, entrepreneur, merchant banker, and founder of Ruffolo Benson LLC, and Paul Clarke, who gave generously of his time and treasure to the founding of the Community Foundation of Greater Fort Wayne. (Courtesy of the *Journal Gazette*.)

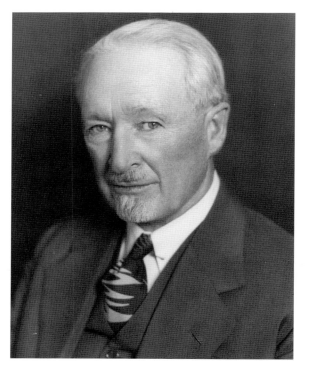

Arthur Hall (1872–1942)

From the time Lincoln National Life Insurance Company was founded in 1905 until his retirement in 1939, the same year Lincoln reached $1 billion of insurance in force, Hall was the driving force of the company. He not only directed the nascent company from its inception, he was also an energetic civic leader and promoter of Fort Wayne. When International Harvester expressed interest in Fort Wayne, it was Hall who organized and headed up the Development Corporation, enlisted other leading citizens to join the cause, and met Harvester's infrastructure and new housing needs. (Courtesy of ACFWHS.)

Albert Neuenschwander (1882–1959)

In 1917, Neuenschwander and his pastor Aaron Souder cofounded and directed what would become Brotherhood Mutual Insurance Company, one of the nation's largest exclusive insurers of churches and related ministries. In 1939, he moved the growing organization from its small Grabill headquarters to 634 West Wayne Street at Broadway (pictured). Today, the company is located in a modern 155,000-square-foot facility near I-69 and Coldwater Road. From its first year's income of $943.93, the company, now under the leadership of Pres. Mark Robison, exceeds $450 million in assets and insures more than 50,000 churches and ministries. (Courtesy of Brotherhood Mutual Insurance Company.)

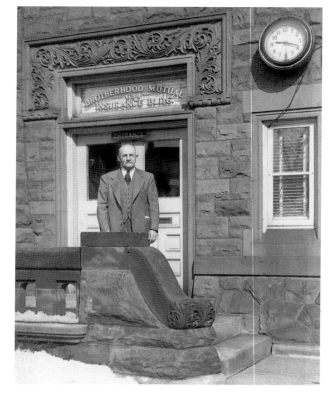

Ian M. Rolland

Ian Rolland graduated from North Side High School and went on to DePauw and then the University of Michigan, where he received his master's degree in actuarial mathematics in 1956. During his college years, his father, through a friend, was able to get him a summer job working for Lincoln National Life Insurance Company, which had been founded in Fort Wayne in 1905. A few years earlier, while at Oakwood Park Summer Camp at Lake Wawasee as a teenager, he had met Miriam "Mimi" Flickinger of Kendallville, whom he married in 1955. Together they raised five children. To say those two events would forever change Lincoln and the city of Fort Wayne would certainly be an understatement. Ian started full time at Lincoln in 1956, became a senior vice president in 1973, president in 1975, and was the CEO from 1977 until his retirement in 1998. Rolland made his largest early impact when in 1966 then-CEO Henry Rood asked him to develop a variable annuity product, creating not only something new for the company but for the industry as well. This product resulted in an explosion in growth through the years, and now 50 years later, variable annuities are the largest business unit in the company. As CEO, Rolland further grew the company by making over a dozen major acquisitions within the financial services industry, and under his leadership Lincoln's assets would grow from $6 billion to $88 billion. However, more than just one of the largest local employers, separately and as a team, Lincoln National Corp., Ian, and his wife, Mimi Rolland, have made large and lasting changes to the city as impactful community activists, civic leaders, and philanthropists. One of the most publicized group efforts led to desegregation of the city's schools through the funding and support of Parents for Quality Education with Integration. Rolland also raised the company's commitment to philanthropic giving from half a percent of pre-tax income to two percent and stipulated that the company would not fund any not-for-profit organization or agency that did not have either women or minorities on its board. The Lincoln Financial Foundation was instrumental in creation of Headwaters Park and funds many local nonprofits each year. Through the Rollands' generosity, the Ian and Mimi Rolland Foundation are large supporters of the arts and numerous local civic and nonprofit endeavors. (Courtesy of the *News Sentinel*.)

Tim Ash

After working in the insurance industry for several years, Jim Ash founded Ash Brokerage in 1971. The family-owned business is now the largest privately held insurance brokerage agency in the United States, serving insurance agents and financial advisors nationwide. Since 1996, under the direction of his son, company CEO Tim Ash, services are provided to more than 10,000 insurance and investment professionals across the country with offices in 16 states. Ash's $29-million investment at Ash Skyline Plaza will soon be housing its headquarters in a new 95,000-square-foot building on Harrison Street. (Courtesy of the *Journal Gazette*.)

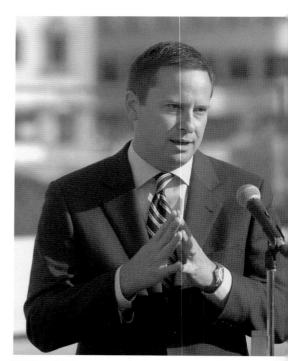

Dr. Rae Pearson

CEO and founder of Alpha Rae Personnel, Inc. in 1980, Dr. Pearson has been repeatedly recognized as one of Indiana's outstanding businesswomen and has received the state's highest honor, the Sagamore of the Wabash. The owner of the successful executive search firm and staffing recruiter, she has employed as many as 2,500 contract workers in multiple states in a single year. A radio talk show host with the program *E-Diva & Friends*, Pearson has also authored books on entrepreneurship and customer service. The sought-after public speaker in the areas of workforce development, single parenting, and entrepreneurship also actively serves on numerous state and local boards and is a noted expert on economic development. (Courtesy of Alpha Rae Personnel, Inc.)

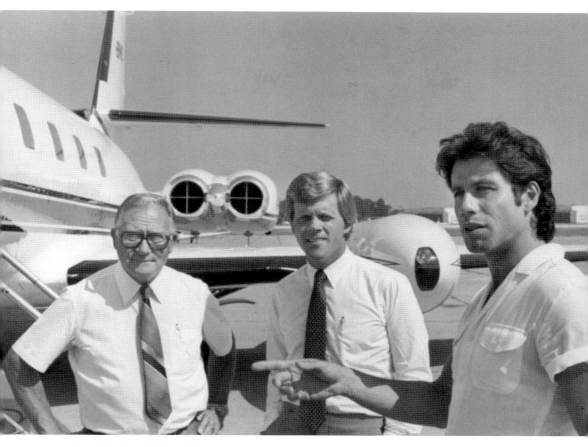

James "Jim" Kelley (1918–2005)

Kelley turned his passion for automobiles, airplanes, and golf into successful businesses. He entered the car business in 1952 with the purchase of a Plymouth Dodge dealership and in 1954 bought a Lincoln Mercury store. Later selling both, he found his niche with General Motors, started Jim Kelley Buick, and then continued to grow his business from there. Eventually, under the umbrella of the Kelley Automotive Group, he had dealerships in Indiana, Florida, and Georgia. He had started Fort Wayne Leasing in 1954, which focused on trucks, tractor/trailer leasing, and rentals, which he then sold to Ryder Truck Rental in 1979. Cofounder of Kelley Flying Service at the old Myer Field, he moved his company to Baer Field and renamed it Fort Wayne Air Service, becoming the airport's fixed base operator. By the 1980s, he was one of the nation's leading independent resellers and lessors of corporate jets. Pictured above in 1983 are, from left to right, Jim Kelley, son Tom Kelley, and actor/pilot John Travolta, who was in town to consider purchasing a plane. Kelley was also the major benefactor of the Greater Fort Wayne Aviation Museum. A golf enthusiast, he owned Fairview and Brookwood Golf Courses and cofounded the Jack Nicklaus–designed Sycamore Hills Golf Club with his son Tom. Jim gave generously to numerous local projects and organizations, not the least of which were the McMillen Center, Fort Wayne Rescue Mission, Boys and Girls Club, Washington House, and Canterbury School, to name but a few. Indiana governor Frank O'Bannon declared him Indiana's citizen of the year in 2001 and awarded him the Sagamore of the Wabash. (Courtesy of the *News-Sentinel*.)

Aloysius Riegel (1863–1938) and Frank Bougher (1862–1920)
In 1905, Al Riegel purchased the Corner Cigar store at the northeast corner of Main and Calhoun Streets. The descendants of Riegel (right) and his brother-in-law Frank Bougher (left), who married each other's sisters, still run the oldest continuously operated retail store in the city. Constructing a new building at the same location in 1919, including a 28-stool lunch counter, it became the hub of activity at its Transfer Corner location. With the City-County Building being erected, they moved across the street to Riegel's current location in 1967. (Courtesy of ACFWHS.)

Richard "Dick" Stoner
Albert Stoner was an amateur magician and all the inspiration his son Dick needed when in 1948 he became a professional magician. Opening Stoner's Magic Shop in 1949, he has been in the prestidigitation/comedic magic business ever since. He traveled the world doing trade and stage shows and shared the limelight with notables like Johnny Cash and Dolly Parton, which led to continuing roles on both the *Nashville Now* and *Statler Brothers* shows. Nationally known, he was the entertainment for Muhammad Ali's 50th birthday party. (Courtesy of Stoner's Fun Store.)

Greg Jacobs

Greg Jacobs has made a career out of building relationships between people, art, and technology. His past endeavors include the Spectator, precursor to Cinema Center, and Science Collective, which became Science Central. A current project, TekVenture, brings the maker movement to Fort Wayne; an annual Maker Faire is now held at Headwaters Park. TekVenture has created a permanent home on Broadway that includes facilities for wood and metal working, sewing, computer-aided design, CNC machining, welding, and three-dimensional printing—a new technology that promises to fundamentally restructure the way products are made.

Barry LaBov

Barry LaBov founded LABOV Marketing Communications in 1981, and it has grown to serve a client list that includes many of the world's most prestigious brands from its Fort Wayne headquarters. Entrepreneurial, innovative, and philanthropic, LaBov created the 12 Hours of LABOV, an entire pro bono day (12 hours) with all company resources focused on one worthy local nonprofit organization, creating advertising, strategy, and marketing for them. Recent recipients are Kate's Kart and Community Harvest Food Bank. An author, columnist, and thought-leader in branding, engagement, and ethics, LaBov has been awarded Entrepreneur of the Year twice, in addition to being recognized for the highest ethics by the BBB. (Courtesy of LABOV Marketing Communications.)

Theodore Hagerman (1908–1999)

German immigrant William Hagerman (1879–1944) started a construction business in 1908; in 1939, he and his sons Theodore and William created Hagerman Construction Co., which became one of the preeminent builders in the city. Ted Hagerman graduated from Purdue's School of Civil Engineering. They built more than 100 schools, 30 hospitals, and buildings at Purdue, Indiana, Ball State, and Valparaiso Universities. They also built the City-County Building (now Rousseau Center, shown below), Memorial Coliseum, Arts United Center, and Foellinger-Freimann Botanical Conservatory. The firm has been carried on by Ted's son and grandsons. As the Hagerman Group, they expanded the coliseum in 2003 and built Parkview Field, the Harrison, and Ash Skyline Plaza developments downtown. (Above image courtesy of Hagerman Construction; below image courtesy of ACPL.)

CHAPTER FOUR

Cultural Figures, Entertainers, and Athletes

One of the great bounties of the progress of civilization is that once the general standard of living has gotten beyond subsistence, there is the option of making a life out of self-expression, or at least having the free time to engage in either participating in or observing the self-expression of others. This can be done in a number of ways. One is simply the contemplation of the world for the sake of understanding it or expressing a reaction to it. This can take the forms of historiography, literature, or the visual arts. Another is to entertain or be entertained; this can take the form of theater, its technological cousin film, music, or competitive sports, either as an individual or as a member of a team.

The growth of Fort Wayne in all these areas of cultural endeavor has been a function of the conquest of the frontier, the growth of the city, and its integration into a larger culture. One unfortunate aspect of this has been that no matter the form of self-expression a person in Fort Wayne has pursued, often this has translated into going elsewhere for the sake of greater opportunities. Fortunately, many such accomplished individuals have, for a variety of reasons, either returned here to live or retained a sentimental connection to the scenes of their earliest triumphs and expressed it in terms of their presence, their philanthropy, or both.

The Hamilton Women

The granddaughters of Allen Hamilton, the Hamilton sisters, from left to right, Norah, Margaret, Alice, and Edith, grew up in a mansion on what had once been their grandfather's farm (present site of Central High School). After her retirement as headmistress of the Bryn Mawr School in 1922, Edith (1867–1963) became a preeminent scholar of classical antiquity; she wrote best-selling books about Greek and Roman civilization as well as a guide to classical mythology. Alice (1869–1970) worked with Jane Addams at Hull House, a settlement house in the Chicago slums. A trained physician, she became an expert on diseases caused by factory conditions. She was the first woman on the medical faculty of Harvard as a professor of public health and was a special investigator for the US Department of Labor. In 1892, Margaret (1871–1969) arranged for the remodeling of a carriage house on the Hamilton grounds for use as an art studio and funded the early years of what became the Fort Wayne Art School; she studied biology in Paris and Munich after graduating from Bryn Mawr, where she later taught science during her sister's tenure and succeeded her as headmistress. Norah (1873–1945) studied art in Paris with James McNeill Whistler (whose grandfather had been commandant of Fort Wayne). She was active in the Art League in Fort Wayne in the 1890s and later taught drawing at Hull House, where she also illustrated books for Jane Addams as well as her sister Alice's autobiography. Their cousin Agnes Hamilton (1868–1961) was also a talented artist who asked her friend Marshall Mahurin about becoming an architect; she instead settled on a career in social work and was a founder of the Fort Wayne YWCA. In 2005, Dr. Patty Martone founded the Hamilton Society of Sisters to honor superlative women ages 13 to 18; she had also conceived and saw to completion the statues of three of the Hamiltons, which have graced Headwaters Park since 2000. (Courtesy of Schlesinger Library, Radcliffe Institute, Harvard University.)

**Dr. Patricia "Patty" Martone
(1930–2012)**
FWCS teacher, assistant superintendent, writer of over 100 *News-Sentinel* guest columns, public speaker, historian, and community activist only begin to describe Patty Martone, a woman who loved life and living in Fort Wayne. She conceived and had built the heroic statuary grouping of the Hamilton women in Headwaters Park and formed the honor society that recognizes superlative young women of the city. On numerous boards, she was also a *Journal Gazette* Citizen of the Year. Patty shared her life with local athletic legend, coach, and sports organizer Tony Martone. (Courtesy of the *Journal Gazette*.)

Betty Stein
After a career as both a teacher and administrator in Fort Wayne Community Schools, spent largely at the Memorial Park School, Betty Stein became a featured journalist at the *News-Sentinel*. For many years, she did a local history series, On This Day, as well as writing guest columns that reflect upon local people and events and the ways they inform the present. Her greatest love has been promoting literature through the coverage of writers and readers in her Page Turner feature, in which she interviews a prominent local person about what they like to read and what specific works they have most recently read. (Courtesy of Capture Photography by Neal Bruns.)

Frank Gray

Starting as a reporter in 1982 for the *Journal-Gazette*, Fort Wayne's morning newspaper (family-owned since 1863), Frank Gray has developed a unique personal voice as one of the paper's most prolific writers. Though he had a stint as business editor, since 1998 he has written a thrice-weekly column about local people and events that reflects his preoccupation with understanding and explaining the human condition. His years of experience have made him both an astute observer of humanity and a person who finds it hard to suffer fools gladly, no matter their prominence. In that sense, he personifies his newspaper's best traditions as a forum for heartfelt opinions. (Courtesy of the *Journal Gazette*.)

Kevin Leininger

Kevin Leininger is likely the person most people would regard as personifying the *News-Sentinel*, Fort Wayne's afternoon newspaper (and its oldest, dating from the 1833 *Sentinel*). He has covered local events long enough to have developed a historical perspective on events. His stories usually contain an element of analysis and an exposition of his own political philosophy of limited government and personal responsibility and are informed by his love of his hometown. He also hosts a weekly interview program, *The Fort Report*, which airs on a local cable channel and is posted on the *News-Sentinel*'s website. (Courtesy of the *News-Sentinel*.)

Marcia Adams (1935–2011)
In 1988, Marcia Adams published *Cooking from Quilt Country*, a collection of 200 family recipes described as "a culinary folk history of the Indiana Amish and Mennonites." She followed this with four other books in a similar vein, the last in 1995; each was turned into a nationally syndicated series on public television, as well as being shown worldwide on the Armed Forces Network. Coronary problems in 1996 led to a heart transplant in 2001; she turned this experience into two books and a PBS documentary. She was also active in the local arts community as a fundraiser for the construction of both the Arts United Center and the Fort Wayne Museum of Art. (Courtesy of the *Journal Gazette*.)

Michael A. Martone
Son of well-known local educator, writer, and community activist Patty Martone, Michael has written 12 books, utilizing the literary genre false biographies. With his prose drawing primarily on experiences in Fort Wayne and the state of Indiana, in writing circles he is considered a literary prankster, regionalist, and formalist. Best known for *Fort Wayne is Seventh on Hitler's List* (1990), *The Blue Guide to Indiana* (2001), and *The Flatness and Other Landscapes* (2003), he is a professor at the Program in Creative Writing at the University of Alabama and was named Indiana Author of the Year in 2013. (Courtesy of Theresa Pappas.)

Harvey Cocks

Harvey's father, a theater operator, passed through Fort Wayne three times before finally settling here to manage the Embassy Theater. After graduating from South Side High School, Cocks spent 26 years acting on Broadway and in stock companies. In 1956, he married actress Jean Hanson; in 1971 they moved to Fort Wayne to help his father manage Quimby Village. Cocks only intended to stay a few months, but his wife decided she liked the city. Cocks, pictured with playwright/actress Nancy Carlson Dodd, was director of Youtheatre for 35 years. During that time, some 16,000 students participated in its productions. In 2013, Harvey Cocks was the first recipient of the Stanley Liddell Award. (Courtesy of the *News-Sentinel*.)

Larry Wardlaw

Though his professional life has been as a senior vice president for account services of the Asher Agency, an advertising and public relations firm, Larry Wardlaw has put his degree in theater from IPFW to good use. He has appeared in or directed productions of every theater group in the city, as well as being involved in Arena Dinner Theater finding a permanent home in West Central. Because of his ability to reconcile conflicting points of view (often with humor), he is in great demand as a member of boards and committees. (Courtesy of the *News-Sentinel*.)

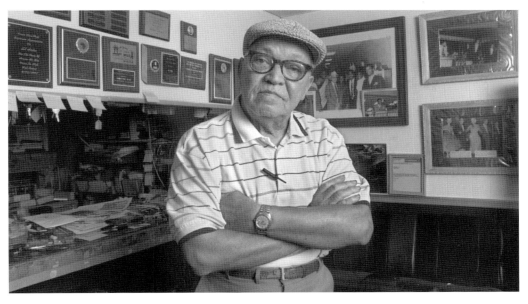

Al Stiles (1922–2014)
A song and dance man who performed most notably at the Apollo Theater in Harlem and the New York World's Fair of 1939, Stiles shared stages with Josephine Baker, Ella Fitzgerald, Duke Ellington, Charlie Parker, and Sammy Davis Jr. When drafted during World War II, Stiles was stationed at the Army air field that became today's Fort Wayne International Airport. He decided to settle here after the war and opened his Talent Factory on Anthony Boulevard in the 1980s as a way to teach inner-city children singing, dancing, and acting. (Courtesy of the *News-Sentinel*.)

Liz Monnier
Monnier was a founding member of Fort Wayne Dance Collective in 1979 and served as artistic director from 1985 to 2015. Funded in part by Arts United, Dance Collective provided space for thousands of local students to attend classes Monnier designed for in-school and after-school children, people with disabilities, seniors, preschoolers, and others, offering styles as diverse as jazz, hip-hop, modern, ballet, tai chi, and yoga. In recent years, she undertook extensive training and certification in the Feldenkrais method, which is designed to reduce pain and limitations in movement and give greater ease of movement and general wellbeing. (Courtesy of Steve and Jenni Vorderman, Vorderman Photography.)

Robert Goldstine (1916–2001)

Goldstine was the third generation of a commercial realty business. His skills were invaluable in 1972, when he was part of a small group of volunteers who negotiated the purchase of the Embassy Theater from a bankrupt theater chain, Cinecom. The owners gave the group six months to raise $250,000 to buy the property; the fund drive began on March 1, 1975. After cleaning and making minor repairs to the building, the volunteers opened the theater to the public for weekend tours and began taking donations and selling memberships in the new Embassy Theater Foundation. The story of the fund drive appeared in the nationally-syndicated comic strip *Gasoline Alley*. After a two-month extension of the deadline, the building was saved. Bob Goldstine served as president of the foundation for its first seven years and remained on the board thereafter; in 1996, a $5.1-million restoration was completed. Though he never pursued the dream of becoming a concert organist, he was a talented musician who saw the theater's Grand Page organ fully restored and played it on many occasions to accompany films, as did another notable organist, Buddy Nolan. (Courtesy of the *News-Sentinel*.)

Heather Headley
Born on the island of Trinidad, Headley moved with her family to Fort Wayne in 1990. At Northrop High School, she sang and danced in the Charisma show choir, played the Fanny Brice lead in the school's production of *Funny Girl*, and was in the Civic Theater. A Tony and Grammy Award–winning singer, songwriter, and actor, in 1997 she originated the role of Nala in the hit musical *The Lion King*, and in 2000, the lead in Elton John's *Aida*. In addition to her Broadway cast albums, Headley has recorded four albums of her own, including the Grammy-winning *Audience of One*. (Courtesy of the *News-Sentinel*.)

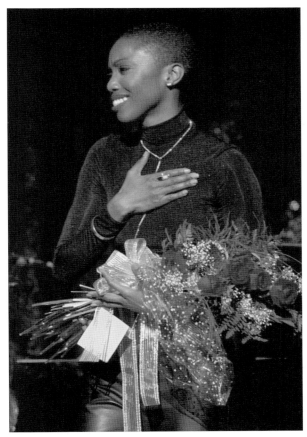

Joseph "Joe" Taylor (1921–2011)
An Indiana institution since its founding in 1948, Joe Taylor, the "Cowboy Auctioneer," and the Indiana Redbirds entertained country and Western music crowds and called square dancing for 50 years. For 17 years, along with his sister-in law Patty Corbat (pictured), Joe and the Redbirds could be heard every Saturday from 12:00 to 1:00 pm on WGL. A staple at the legendary Buck Lake Ranch near Angola, Joe and his Redbirds fronted for such notables as Johnny Cash, the Everly Brothers, Dolly Parton, Buddy Holly, and the Lennon Sisters. (Courtesy of the *Journal Gazette*.)

Charles W. "Commodore Foote" Nestel (1848–1937)

Born in Fort Wayne to average-sized parents, Nestel at three feet, five inches, with his diminutive sister Eliza, spent over half a century traveling the world performing with various troupes, including The Little People, P.T. Barnum, the Royal American Midgets, and the Lilliputian Opera Company. Using the stage names Commodore Foote and the Fairy Queen, the Nestels sang, danced, and performed skits in costume for the public and heads of state alike across Europe and throughout the United States and Canada. Nestel died here in 1937 at age 88. His sister, despondent over her brother's death, passed away a mere 10 days later at 80.

Philemon "Phil" Steigerwald (1927–2004)

Steigerwald's résumé includes owner of Fairfield Realty, noted vocalist who sang the national anthem at the McMillen Park Fourth of July fireworks, Fifth District city councilman during the 1960s and 1970s, treasurer for the Allen County Republican Party, and most importantly, Santa. More than anyone in Fort Wayne's recent history, Phil Steigerwald is identified as being Santa Claus from the 1950s through the 1970s. Steigerwald played the part of Santa at the Wolf & Dessauer department store for 35 years, long enough to have on his lap two generations of children. His red velvet white rabbit fur–trimmed suit is now under the care of the History Center. (Courtesy of the *News-Sentinel*.)

DeLois "Dee" McKinley-Eldridge
Growing up in Bessemer, Alabama, just 13 miles from Birmingham, McKinley participated as a child in civil-rights demonstrations and marches and later in Dr. Martin Luther King Jr.'s first march on Washington. A local resident since 1969, she spent 19 years with the Metropolitan Human Relations Commission, eventually becoming its director. DeLois later became a counselor and case manager for Fort Wayne Community Schools, an Allen County councilmember, and has been a board member and active in a number of civil- and human-rights agencies and organizations. McKinley-Eldridge is also renowned for her over 40 years on-air as host of Fort Wayne's *Gospel Flight* Sunday mornings on WBOI and *The Gospel Express* on WQSW on Sunday afternoons. (Courtesy of the *News-Sentinel*.)

Robert "Bob" Sievers (1917–2007)
Known as "Mr. WOWO," Bob Sievers was a Fort Wayne institution on local radio for over 50 years, starting his career when he was in high school at South Side and retiring in 1987. For decades, he hosted the early-morning *Little Red Barn* program, followed by his own show from 7:00 to 10:00 am. Broadcasting on the 50,000-watt station, *The Bob Sievers Show* was one of the highest-rated morning programs in the country for a number of years. Sievers's contemporaries over the years at WOWO included the familiar names of Bob Chase, Jack Underwood, Jay Gould, Don Chevillet, Art Saltsberg, Dugan Fry, Ron Gregory, and Chris Roberts. (Courtesy of the *News-Sentinel*.)

Julia Meek

Self-described Forthead, the ubiquitous Julia Meek has painted the town "her way" since 1969. Three dozen Easter Seals ARC cityscapes, multiple Mastodons on Parade, hundreds of private commissions and commercial designs, and Hyde Brothers Bookstore's *Fort Wayne Story* mural attest to her graphic-art centricity. Adding public radio to her palette in 1980, she colors NIPR's airwaves weekly, with her syndicated *Folktales*, arts reporting, and *Meet the Music* sound stage. Canal Society of Indiana cofounder, official Three Rivers Festival millennial artist, volunteer extraordinaire, and community connector are a few of the appointed titles that forge Meek's bond with her world that is as diverse and colorful as the artist herself. (Courtesy of the *Journal Gazette*.)

Rick "Doc" West

Born in Columbus, Ohio, and raised in Miami and Key West, Florida, the "Doc" went on local airwaves at age 27 and is still "rock-only" on the radio after 35 years. Having met and interviewed most of the rock acts from the late 1960s through the 1990s, West is renowned for his obvious love of rock music, spontaneity, and internally wired encyclopedia of rock music. The classic-rock station Fort Wayne listeners could depend on hearing him on since 1979, WXKE Rock 104 (103.9), changed in 2014 to 963XKE (96.3), which allowed the signal to ramp up from a local 3,000 watts to a regional 25,000. (Courtesy of the *Journal Gazette*.)

Jack Hammer

Tom Jaxtheimer, fourth-generation Fort Wayne resident, also known as Jack Hammer of local radio fame, had a successful 25-year career on air with stations such as 98.9 the Bear, X102, and 92.3 the Fort. After his radio success, in 2010, he reinvented himself as the executive director of the Three Rivers Festival, at a time when its image had been tarnished. Hammer and the newly energized board of directors put the festival back on the rivers, brought in multiple new local businesses as major sponsors, brought back the raft race, and significantly improved the nine-day, 80-plus-event community celebration. (Courtesy of Capture Photography by Neal Bruns.)

Barb Richards

Most people recognize the voice of Richards, who had a 30-year career as a community-minded radio personality. At Majic 95.1, she worked with national recording artists and Sweetwater Sound to create the *Majic Miracle Music* CD as a fundraiser for Riley Hospital for Children. She also developed the Majic Christmas Wish program that granted thousands of wishes to area residents and was a champion for the Vera Bradley Foundation. In 1999, Barb organized a mile-long prayer chain made up of messages written by listeners on strips of construction paper that was delivered to the students of Columbine High School after the 1999 shootings. (Courtesy of the *Journal Gazette*.)

John Siemer (1922–2011)

When the city's first television station, WKJG, went on the air in 1953, John Siemer was among its first announcers, doing news, commercials, and station breaks. From 1954 until 1971, he donned a bandanna, striped grey coveralls, and an engineer's cap to become "Engineer John," host of what was originally called *Cartoon Express with Engineer John* and later *The Engineer John Show*. He was the first local television personality for children, making appearances in costume at schools and special events. As such, he became an iconic performer to members of the Baby Boom generation in Fort Wayne. (Courtesy of ACPL.)

Dr. Nancy Snyderman

A South Side High School graduate whose father and grandfather were doctors, Snyderman received a degree in microbiology at IU and her doctorate at the University of Nebraska medical school in 1977. She served as a medical correspondent for ABC News for 15 years and since 2006 had been chief medical editor for NBC News, frequently appearing on the *Today* show, NBC Nightly News, and MSNBC prior to leaving the network in 2015. Author of five books, in 2013 she launched a website where she answers health and medical questions. She is also cofounder of CarePlanners, a service that helps patients and caregivers navigate the healthcare system. (Courtesy of the *Journal Gazette*.)

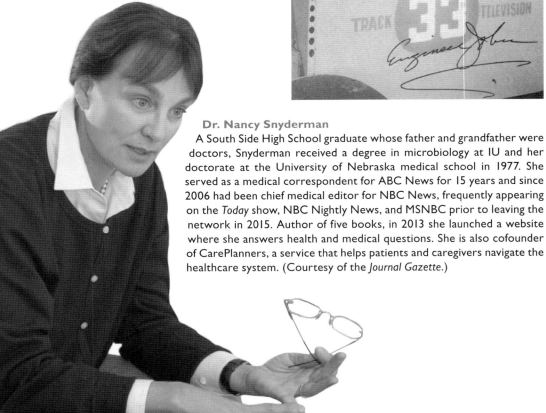

Ann Colone (1930–2007)
A well-known local star in many Civic Theater plays, Ann, pictured here with actor Lloyd Bridges, is best remembered for 17 years of appearances on her *Ann Colone Show* on Channel 15, WANE-TV, from 1958 to 1976. During the show, she interviewed local, celebrity, and distinguished guests alike in front of a live studio audience. Her list of guests read like a Who's Who of the era and included the Rolling Stones, Bob Hope, John, Bobby and Teddy Kennedy, Frank Sinatra, Woody Allen, Elvis Presley, Walter Cronkite, and hundreds more. (Courtesy of the *News-Sentinel*.)

Hilliard Gates (1915–1996)
Born as Hilliard Gates Gudelsky in Michigan, the sportscaster dropped his last name when he started broadcasting in 1936. Moving here in 1940 to take a job at WOWO, Hilliard switched to WKJG in 1947, later becoming the station's vice president and general manager. Gates was the first person to appear live on Fort Wayne television and called games for the Zollner Pistons, Indiana, Purdue, and Notre Dame football, the Rose Bowl for NBC, live coverage of the Indianapolis 500, and hundreds of high school basketball games. He announced the play-by-play for the classic 1954 Milan-Muncie basketball game and reprised his role for the 1986 movie *Hoosiers*. (Courtesy of the *News-Sentinel*.)

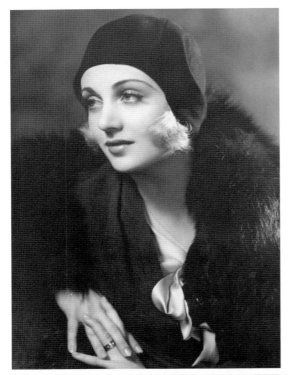

Carole Lombard (1908–1942)

Lombard, who was born in Fort Wayne as Jane Alice Peters, grew up as part of a well-to-do Fort Wayne family and lived at 704 Rockhill Street at its intersection with Thieme Drive. Moving to Hollywood with her mother, Lombard—having been noticed by a film director—at age 16 signed a contract with Fox Film in 1924. Usually playing the part of a comedic screwball, she starred opposite the biggest Hollywood names of the 1930s, including John Barrymore, William Powell, Gary Cooper, Shirley Temple, Fred MacMurray, James Stewart, Charles Laughton, Robert Montgomery, Jack Benny, and Clark Gable. In 1937, she was one of Hollywood's most popular actresses, nominated for an Academy Award for *My Man Godfrey*, and the highest paid female star in the industry, with Paramount paying her $450,000 per year, which was then five times the salary of the US president. She and Gable married in 1939 and bought a 20-acre ranch in Encino, California. Lombard traveled to Indianapolis for a war-bond rally in late 1941 and raised over $2 million in defense bonds in a single evening. To the shock of the country, on her way back to California, 13 minutes after refueling in Las Vegas, the military-chartered TWA plane she was traveling in crashed into Potosi Mountain, killing all 22 people onboard instantly, including her mother. In 1944, the government honored her service to the country by launching the Liberty ship SS *Carole Lombard*, which took an active part in the Pacific theater during World War II, and in Fort Wayne, the Main Street bridge over the St. Mary's River is designated as the Carole Lombard Memorial Bridge. (Above image courtesy of ACPL; below image courtesy of ACFWHS.)

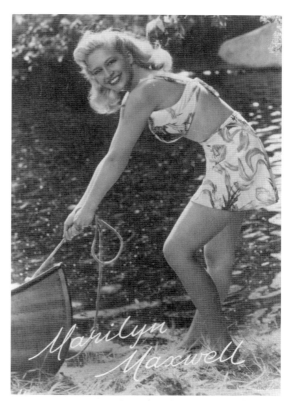

Marilyn Maxwell (1921–1972)

Born Marvel Marilyn Maxwell, and one of the sex symbols of the 1940s and 1950s, she was often referred to as "the other Marilyn." Maxwell attended Central High School, was an usher at the Rialto Theater in the mid-1930s, and dropped out of school in her sophomore year to join an Indianapolis band as a singer. She performed on radio throughout her life. She was still a teenager when she signed with MGM, whose owner Louis B. Mayer convinced her to drop her first name. In more than 30 movies beginning in 1942, she played opposite legends like Clark Gable, Mickey Rooney, Gene Kelly, and Kirk Douglas. Maxwell is remembered for singing the Christmas carol classic "Silver Bells," which debuted in the movie *The Lemon Drop Kid* with Bob Hope. She and Hope traveled widely doing USO tours during World War II and the Korean Conflict and had a longstanding relationship. On television, she appeared on the *Jimmy Durante Show* and Tennessee Ernie Ford's variety show. She died of an apparent heart attack at age 50, with the honorary pallbearers at her funeral being Bob Hope, Bing Crosby, Frank Sinatra, and Jack Benny. A close friend of Rock Hudson, she helped conceal his homosexuality by making frequent public appearances with him. (Courtesy of ACPL.)

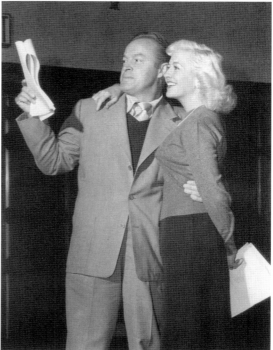

Shelley Long

An Emmy Award and Golden Globe–winning actress best known for playing Diane Chambers in the sitcom *Cheers*, Long grew up in Indian Village, was on the speech team at South Side, and attended Northwestern University. Her professional career started in Chicago, acting in commercials and as a member of the famed Second City Comedy Club. She made her Hollywood debut in 1978 in *The Love Boat* and has appeared in other television shows, including *Boston Legal* and *Modern Family*. Long's movie career includes *The Money Pit* with Tom Hanks, *Outrageous Fortune* with Bette Midler, and *Troop Beverly Hills*. (Courtesy of the *Journal Gazette*.)

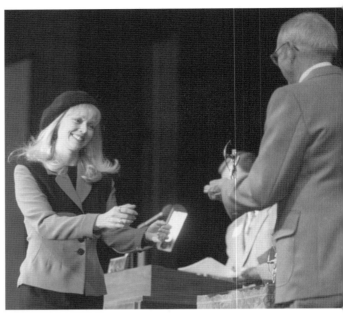

Margaret Ray Ringenberg (1921–2008)

Fort Wayne native Ringenberg had her first solo flight and got her pilot license at age 19 in 1941. During World War II, she joined the Women Airforce Service Pilots (WASP), and while women pilots were not allowed to fly in combat, she spent the war ferrying military planes, test flying, and towing targets. Becoming a flight instructor and commercial pilot, she continued flying, including completing a round-the-world air race at age 72, and at 79, a race from London, England, to Sydney, Australia. An accomplished racer nationally in the powder-puff derbies and air race classics with over 40,000 hours of flying time, Tom Brokaw devoted a chapter to her in his book *The Greatest Generation*. (Courtesy of the *News-Sentinel*.)

H. Stanley "Stan" Liddell Jr. (1936–2013)
The visionary Liddell purchased the Marketplace of Canterbury in 1984 and over time transformed it into the area's live-music entertainment mecca with his Piere's Entertainment Center. The complex was comprised of five different themed nightclubs, including a million-dollar stage on which hundreds of artists performed, from Kid Rock to the Doobie Brothers. Liddell also founded Picasso's banquet hall and catering service, both the House of Jazz and Blues and Flashbacks dance club on the landing, Tater Junction, the first restaurant at the Glenbrook Square Ice Rink, and acquired the upscale Trolley Bar restaurant on Dupont Road. Always tinkering and looking for new concepts to develop, he also hosted numerous charity benefits to help the community. (Courtesy of the *Journal Gazette*.)

Robert "Bob" Roets
A champion of local Fort Wayne music, Bob opened the first of his three existing Wooden Nickel music stores in 1982. The former Wisconsin native moved here to manage Slatewood Records and then at age 23, with his wife, Cindy, opened his own store on North Clinton Street. Roets's three decades of staying power has made him the primary supplier of both new and used vinyl, CDs, and cassettes. One of his hallmarks has been giving exposure to bands with in-store signings and live performances, of which he has hosted over 350, the overseeing of the battle of the bands each year hosted by Columbia Street West, his annual Record Store Day held each April, and of course, those famous Wooden Nickels. (Courtesy of Cindy Roets.)

Homer G. Davisson (1866–1957)

Homer Davisson was long one of the leading figures in the city's art community. Davisson initially studied art at DePauw University; though he never graduated, the school lists him among its foremost alumni. After brief stints at a number of art academies in the United States and Germany, Davisson returned to the United States in 1910. He eventually taught at the Fort Wayne Art School that had begun in the Hamilton carriage house; by the time he became the school's director in 1911, it was located in a house at the northeast corner of Webster and Wayne Streets. He was also a founding member of the art colony in Brown County. In 1927, he moved to the house and studio at 331 West Pontiac, where he lived the rest of his life; the 1893 studio building remains. Davisson made summer income by organizing European study tours in the 1920s. He became the center of a faculty that included Norman Bradley, George and Sue McCullough, Noel Duesenchon, Russ Oettel, Don Kruse, Leslie Motz, and Hector Garcia. In 1953, the school had a retrospective exhibit of his work. At the time of his death, he was hailed in the Fort Wayne and Indianapolis papers as "the dean of Indiana artists." His easel, palette, paint box, and brush vase are in the collection of the Fort Wayne Museum of Art, as well as a bronze bust of him made by a fellow faculty member. His paintings reside in museums and galleries in the United States, Netherlands, and France. (Courtesy of ACFWHS.)

Louis Bonsib (1892–1979)

While a senior at Indiana University, Bonsib was editor of the yearbook; it caught the attention of the Indianapolis Engraving Co., which gave him a job. His success there led him to start his own advertising agency seven years later, locating in Fort Wayne in 1924. Early clients included the Wayne Pump Co.; he provided the slogan, "Fill 'er up!" to promote their self-measuring pumps that calculated the cost of sales. Another client was Magnavox, where his teenage experience with ham radio was a plus. By 1941, the agency had a list of 100 clients. While building his business, Bonsib became an accomplished landscape painter, exhibiting in both the Hoosier Salon and the Brown County Art Gallery. (Courtesy of ACFWHS.)

James "Jim" McBride (1923–1980)

A noted watercolorist, McBride studied at the Fort Wayne Art School and several other academies. In 1957, he eulogized his friend and mentor Homer Davisson. He is best known for his Indiana landscapes and depictions of Fort Wayne buildings, which he produced as both prints and note cards. He painted several murals, including one at the Takaoka of Japan restaurant. He was art director at WKJG until 1959 and art editor of the *Our Sunday Visitor* magazine for a decade after that. At the time of his death, he was the proprietor of his own gallery in Fort Wayne. (Courtesy of the *News-Sentinel.*)

Betty Fishman

Along the way while teaching art to middle and high school students in Noble County for 22 years, Betty Fishman became an accomplished artist, appraiser, and gallery curator. She was president of the Fort Wayne Art School during one of its most tumultuous periods, the late 1960s, where she also taught for a decade. From 1991 until 2005, she was executive director of the independent nonprofit gallery Artlink, where she critiqued and mentored many young artists. She says she has lived "in a curious and fearless desire to explore the world and . . . cope with whatever possibility was presented." (Courtesy of the *Journal Gazette*.)

Jody Hemphill-Smith

Jody and her husband, Mark, live in the 1905 B. Paul Mossman House, which was the home of the Fort Wayne Museum of Art from 1950 to 1983. Since 1995, they have not only called this their home; it has also been Castle Gallery, which has become the premier artists' venue in the city. An accomplished painter in her own right, she presides over the city's most popular salon, whose gallery openings have become both artistic and social events. Among the local artists represented by the gallery are Michael Poorman, Fred Deloresco, Andrea Bojrab, Tim Johnson, Maurice Papier, Terry Armstrong, and Douglas Runyan, as well as Jody herself. (Courtesy of the *Journal Gazette*.)

Joel Fremion

After initially considering architecture, Fremion found an art form that he has made uniquely his own: mixed-media fabric collages. His subjects range from landscapes and buildings to portraits of fellow artists. A retrospective of these at the Fort Wayne Museum of Art in 2012 was just the latest in a long series of gallery shows and awards throughout the country, including at the prestigious Hoosier Salon. Fort Wayne has a robust art community with contemporaries of Joel's such as Terry Ratliff, Gwen Gutwein, Karen Moriarty, Steve Perfect, Karen Thompson, Sue and Steve Vachon, to name but a few. (Courtesy of the *Journal Gazette*.)

Hector Garcia

Hector Garcia has done virtually every piece of public sculpture created in Fort Wayne since the dedication of the Henry Lawton statue in 1922. Perhaps his largest commission came in 1967, when he created a series of life-sized busts of the leading figures in literature, art, and the sciences for the new Allen County Public Library. With the exception of the bust of library director Fred Reynolds still on display at the entrance to the genealogy center, the rest are currently stored. Other works include larger-than-life figures of Chief Little Turtle in Headwaters Park and a Jesuit that stand on the grounds of the Three Rivers Water Filtration Plant overlooking the confluence, the bust of John Nuckols in Nuckols Park, and *Transformation*, a bronze in front of the juvenile center on Wells Street. (Courtesy of the *News-Sentinel*.)

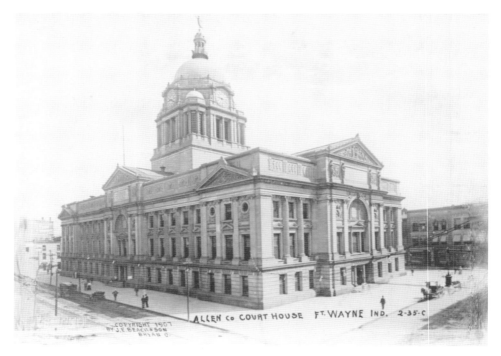

Brentwood Tolan (1855–1923)

Tolan's father, a cut-stone contractor from Delphos, Ohio, came here with his family in 1875 because of the city's good railroad connections. Thomas Tolan (1830–1883) had developed an architectural practice exclusively around entering competitions to design courthouses and jails. His first major building was the 1877 Davis County Courthouse in Iowa; he did six other courthouses and two dozen jails all over the Midwest.

Thomas Tolan's only major commission in Fort Wayne was the Masonic Temple Opera House at the northeast corner of Clinton and Wayne Streets, which was begun in 1880 but only completed to the second floor when funds ran out. Wing and Mahurin completed the building in simplified form in 1884; it burned in 1922.

In 1881, Thomas Tolan decided to make his son chief draftsman in his office; this change enraged John Wing, who held that position. By the time Thomas Tolan returned from a business trip, John Wing and one of the draftsmen, Marshall Mahurin, had left the firm and taken some projects with them.

Brent Tolan continued his father's practice, designing courthouses in Delaware, Whitley, and La Porte Counties. But the crowning event of his career was winning the 1896 competition for the Allen County Courthouse. The massive project was virtually the only thing he worked on until its completion in 1902. He never designed another courthouse. Tolan spent the rest of his career between Fort Wayne and Lima, Ohio, where he was in partnership with Louis LeCurtin. The only known commission of his later career in Fort Wayne is the 1913 expansion of his 1889 Old National Bank Building at the southwest corner of Berry and Calhoun Streets.

If the only work Brentwood Tolan had ever done in Fort Wayne were the Allen County Courthouse, his place in the city's history would be assured. Despite the complaints in his memoirs that he was never a "real architect" because of his lack of formal education, the courthouse design is an elegant statement of the classical revival ideal of architecture as a fusion of all the fine arts. Upon seeing the building's murals, Richard Murray, senior curator at the Smithsonian Institution's National Museum of American Art, said that the rotunda murals were "among the top five or so examples painted during the Progressive period," and that he would have to completely reassess the importance of the Chicago School in American mural painting for a contemplated book on the subject. (Courtesy of ACPL.)

Marshall Mahurin (1857–1939)
After he was orphaned at a young age, Mahurin worked at several jobs before taking a drafting course with a railroad career in mind. Instead, he entered the office of George Trenam, the city's first architect, in 1879. In 1881, he went to Thomas Tolan's office, where he met John Wing; they formed a partnership that lasted 27 years. In 1907, he formed a partnership with his nephew Guy Mahurin that lasted until 1918. He practiced independently until 1928, when glaucoma forced him to retire. He always regarded the Indiana Pavilion at the 1904 St. Louis World's Fair as his best work and kept the drawings of it all his life. (Courtesy of Craig Leonard.)

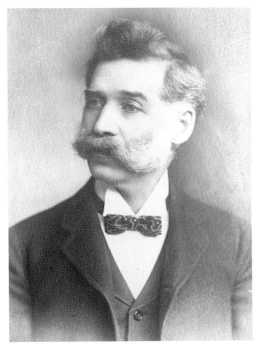

John Wing (1852–1947)
After working for architects in Jackson and Ann Arbor, Michigan, he came to Fort Wayne in the late 1870s to work for Thomas Tolan, for whom he was head draftsman. In 1881, he and Marshall Mahurin (1857–1939) formed a partnership known as Wing and Co. until 1886, when it became Wing and Mahurin—the premier architectural firm in the city for 27 years. Their commission list includes over 350 buildings. With the exception of the Allen County Courthouse, they designed virtually every major structure in the city during their practice. Wing was most proud of his design of Brookside, the John Bass Mansion. (Courtesy of Craig Leonard.)

Charles Weatherhogg (1872–1937)

A native of Donington, Lincolnshire, England, Weatherhogg came to the United States in 1893 to see the Chicago World's Fair, then came to Fort Wayne to visit J. Ross McCulloch, who he had met in England in 1891 (the two men became lifetime partners). He joined the office of Wing and Mahurin and remained there until 1894, when he formed a brief partnership with another British Wing and Mahurin alumnus, Alfred Grindle (d.1940). Weatherhogg became one of the most prolific architects in the city during the early 20th century, designing the Noll Mansion, Central High School, North Side High School, and the Art Smith Memorial. His most notable collaboration was in 1907, when he brought Louis Sullivan from Chicago to consult on the design of the Anthony Hotel (located at the northeast corner of Berry and Harrison Streets), a commission generally missed in accounts of Sullivan's work. (Courtesy of ACPL.)

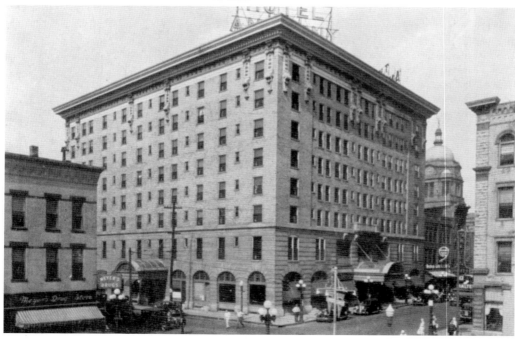

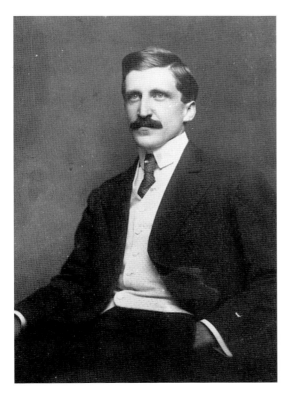

Guy Mahurin (1877–1942)

Guy Mahurin began his career in the offices of Wing and Mahurin. He decided to get a formal education and graduated from the University of Illinois. He took a two-year appointment as chief draftsman in the US Bureau of Architecture in the Philippines, where he designed public buildings and won a competition to design the Filipino Village at the 1904 St. Louis World's Fair. From 1907 to 1918, he was in partnership with his uncle Marshall Mahurin. Among his local works are the Adair Federal Building, Fort Wayne Chamber of Commerce, Scottish Rite Auditorium, and Plymouth Congregational Church. (Courtesy of Craig Leonard.)

Joel Ninde (1873–1916)

What began as a pastime for Joel Ninde became a career. She designed houses for friends that represented a break from Victorian precedent; her designs emphasized cozy informality, kitchens that were not designed just to be used by servants (who were increasingly scarce) and set on lots that no longer had large yards. She did designs in the Arts and Crafts and Colonial Revival styles. She and her husband, attorney Lee Ninde, decided to become not only advocates for better neighborhood planning but also developers who put their ideas into practice through the Wildwood Builders Company. They also published the *Wildwood* magazine and ran full-page essays about design in the *Journal Gazette*. In 1914, Joel opened an architectural office with Grace Crosby. Shawnee Place and the Wildwood Park neighborhood are among her legacies, as well as several hundred houses. (Courtesy of ACFWHS.)

Alvin M. Strauss (1895–1958)

Strauss established his own office in Fort Wayne in 1916, after having worked for John Wing and Charles Weatherhogg, as well as in Chicago. Until the mid-1920s, Strauss was one of a number of local architects, but his career got a boost when he became local supervising architect for two high-profile projects: the Fox theater/hotel project (today's Embassy Theater/Indiana Hotel), designed by John Eberson of Connecticut, who specialized in "atmospheric" theaters and the Lincoln National Bank Tower (now Old National), designed by Walker & Weeks of Cleveland. Strauss parlayed these prestigious associations into a firm that did approximately 5,000 projects. His firm largely defined the appearance of downtown from the 1930s through the 1960s. Fox had Strauss design theaters for them as far away as Los Angeles; he also designed Paramount theaters in Fort Wayne and Anderson as well as in Fremont, Ohio. His school commissions included Central Catholic High School and 13 buildings at Indiana University. Local works include War Memorial Coliseum, Clyde Theater, Parkview Hospital, Veterans Administration Hospital, and the City-County Building (now Rousseau Center). The firm was continued by his nephew Herman Strauss until 1988. (Left image courtesy of ACFWHS; below image courtesy of ACPL.)

Eric R. Kuhne

Devastating floods in 1978 and afterwards led to a search for ways to fundamentally transform that northern part of downtown. This is just the sort of problem that has always appealed to Eric Kuhne, an architect and a former planner in city government. Kuhne proposed clearing the area and transforming it into a landscaped northern approach to downtown that would be a combination of flood mitigation, recreation, and civic life. Headwaters Park provides the city with a natural landscape that fosters civic interaction in its festival pavilion and landscaped gardens. Also, it acts as a major nodal point for the city's Rivergreenway pedestrian trail system, all while accomplishing the goal of flood mitigation. The park was begun in 1994 and largely complete by 2000. Since 1995, Eric Kuhne has headed Civic Arts, an architectural consulting firm based in London. Civic Arts has completed major architectural and landscape projects on five continents to date, most notably the Titanic Museum built on the former Harland & Wolff shipyard in Belfast, Ireland. (Above image courtesy of Eric Kuhne; below image courtesy of the *Journal Gazette*.)

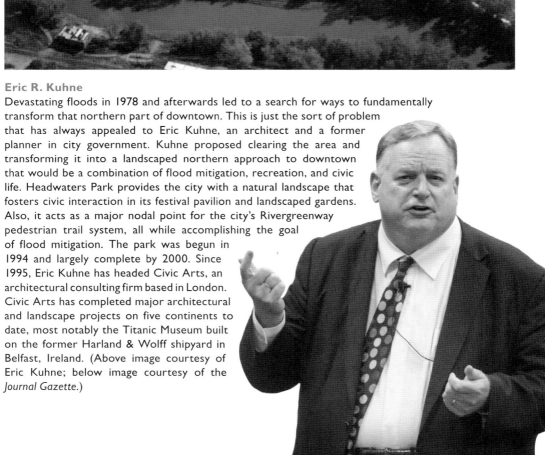

Karen Anderson (1945–2012)

The American Revolution bicentennial in 1976 marked the birth of the modern historic preservation movement. In Fort Wayne, the city bicentennial commission had a committee on historical preservation headed by Karen Anderson. The committee decided to adaptively reuse the 1852 John Brown Block on Superior Street as offices for the Fine Arts Foundation (now Arts United). Anderson pulled together donations of architectural services (Ken Cole), labor (Seabees), and building materials, and the project was realized. She used the committee to highlight the need for a city inventory of historic structures; one was completed in 1981.

On July 24, 1975, the committee incorporated as ARCH, a nonprofit entity; its first project was one of advocacy. The housing authority was demolishing a block of buildings on West Main Street; one that was included was the William S. Edsall House, built in 1839 and the oldest extant structure downtown. ARCH published Thomas Crampton's research about the age of the house, and the project was changed to have the house kept; it eventually became the offices of the Fort Wayne Homebuilders Association. In 1977, ARCH formed a joint venture with the Junior League, Operation Preservation, to create a revolving fund for the purchase and resale of historic properties. In 1980 and 1981, two houses were successfully relocated and sold: the Strunz-Sponhauer House and the Edsall-Brown-Wise House, both relocated to what had been the site of the Rockhill Mansion on West Berry Street. In 1982, Anderson left the helm of ARCH to make an unsuccessful run for city council and later became an antiques dealer, but by that time, historic preservation had been established as a bona-fide civic priority. ARCH continued and became a funded member of Arts United. It has since had several executive directors, including Ann McAlexander, Gretchen Wiegel, Janet Nahrwold, Angie Quinn, and as of this writing, Michael Galbraith. A few of the many volunteers who have contributed to its success are Rosemary Hippensteel, Robert and Mary DeVinney, Robert Michel, Steve Hazelrigg, Harold Lopshire, Michael Poorman, and Craig Leonard. Later projects have included three more house restorations, conducting inventories of historic resources in Allen and several other counties, and annual house tours. (Courtesy of the *News-Sentinel*.)

Bill Blass (1922–2002)

Bill Blass was born and raised in Fort Wayne. In 1939, he went East to attend Parsons School of Design. After World War II, he became a designer for Anna Miller & Co., which merged with Maurice Rentner in 1959. In 1969, he bought the firm and renamed it Bill Blass Limited. Bill Blass became synonymous with elegant clothes executed in luxurious materials, particularly fine tailoring and innovative combinations of patterns and textures. He counted among his clients Nancy Reagan and Nancy Kissinger. In 1999, Blass sold his company and retired at the top of his profession. (Courtesy of ACFWHS.)

Madelane Elston

Madelane Elston has been a prominent volunteer in the cultural life of Fort Wayne for three decades. As a member of the Junior League, she and her friend Karen Anderson organized Operation Preservation; when its first project was organized in 1980, the large mermaid-shaped bracket on the front of the 1884 Strunz-Sponhauer House was dubbed "Madelane." She has also been a stalwart supporter of Arts United, the Fort Wayne Museum of Art, and the Headwaters Park Commission, each of which she has served as a board member. Perhaps her most lasting contribution to the city has been her service first as a volunteer and later as president of the Allen County Courthouse Preservation Trust, which planned, fundraised, and oversaw the eight-year $8.6-million restoration of the Allen County Courthouse and creation of the Courthouse Green, all of which was completed just in time to celebrate the centennial of the building's completion in 2002. (Courtesy of the *Journal Gazette*.)

Albert "Bert" Griswold (1873–1927)
In 1917, Bert published his *Pictorial History of Fort Wayne, Indiana*, which was illustrated with his own drawings of people and artifacts and became the standard work on the subject. In 1926, he published a collection of biographies, *Builders of Greater Fort Wayne*. The *News-Sentinel* reported that when asked about the impact of his work while on his deathbed, Griswold reportedly said, "Two weeks after I'm dead I won't be a subject of conversation." Fortunately, he was wrong; his works remain both highly readable and enjoyable to all audiences.

Eric Olson
If anyone is as prolific a popularizer of local history as Bert Griswold, it is Eric Olson. Over 25 years, he has created more than 2,000 stories of local history, individuals, and events for his *21 Country* segments on Channel 21. As he puts it, "All the years and all the stories amount to a snapshot of a specific corner of America in a specific period of time that says, 'this is who we were and this is some of what we did.'" To appreciate the extent of Olsen's accomplishment, consider that each of those segments was filmed, scripted, and edited in less than a day. (Courtesy of 21 Alive.)

Tom Castaldi

Tom Castaldi spent his working life in corporate America, primarily as vice president for public relations and governmental liaison of the Essex Group, before he retired in 1998. He then started a second career as a public historian. He is perhaps most familiar to area residents for his *On the Heritage Trail* spots on local public radio, WBOI-FM (available as a set of compact discs), as well as the Heritage Trail feature in *Fort Wayne Monthly* magazine; he has written over 90 articles for various publications. Castaldi is the author of the three-volume *Wabash and Erie Canal Notebooks*, which are original works of primary research that he produced in conjunction with the Canal Society of Indiana. He has also been a planner and fundraiser for both the Indiana State Museum (he was its first president) and the Carroll County Wabash and Erie Canal Museum in Delphi, Indiana, as well as the History Center locally. He is one of the foremost among the contemporary local historians, who include John Beatty, Walter Font, George Mather, Scott Bushnell, Walter Sassmannhausen, Michael Hawfield, William C. Lee, Angie Quinn, Clifford Scott, John Martin Smith, Ralph Violette, Roger Meyers, Jason Smith, John Ankenbruck, John Aden, and Charles Poinsatte. (Courtesy of the *News-Sentinel.*)

Fort Wayne Komets

When talk first started in 1944 of building a field house in Fort Wayne as a war memorial, little did the Junior Chamber of Commerce (Jaycees) realize the over 60 years of dasher board–smashing Komet hockey they would be unleashing. Built more with the Zollner Piston basketball team in mind, the Allen County War Memorial Coliseum has been home to the Komets since its opening. Conversely, the Pistons only played there for five years before moving to Detroit in 1957. However, the upstart hockey team founded by hotelier Harold Van Orman, Ernie Berg, and Ramon Perry, and whose first game was on October 25, 1952, played on through a succession of seasons and owners. These included Colin Lister and Bob Ullyot, Bob Britt, and then the owner that moved the franchise to New York in the summer of 1990, David Welker. Fortunately for the players and the fans, never missing a season or a beat, the Franke brothers, Stephen, Michael, David, William Jr., and Richard, with the help of the Popp family, picked up the defunct Flint Spirits franchise and reopened the Komets gates before the 1990 season was underway. With hundreds of great players through the years, the Komets have won four postseason championship titles in the original IHL in 1963, 1965, 1973, and 1993, four in the UHL/second IHL in 2003, 2008, 2009, and 2010, and one in the CHL in 2012. Retired Komet numbers include, No. 1 Chuck Adamson, No. 2 Guy Dupuis, No. 5 Terry Pembroke, No. 6 Lionel Repka, No. 11 Len Thornson, No. 12 Reggie Primeau, No. 16 Eddie Long, No. 18 Robbie Laird, No. 26 Colin Chin, No. 30 Robbie Irons, No. 33 Nick Boucher, No. 40 Bob Chase, No. 58 Ken Ullyot, No. 59 Colin Lister, No. 77 Steve Fletcher, and with no number, Bud Gallmeir. Besides the teammates, the Komets allowed other locals to shine, such as longtime 50,000-watt WOWO's "Mr. Radio Rinkside" Bob Chase, the New-Sentinel's Bud Gallmeier and Blake Sebring, NBC's voice of hockey Mike Emrick, and a host of organ players, announcers, singers of the national anthem, and the diehard fans, the real winners. Standing on the ice in October 2013 are, from left to right, Guy Dupuis, Colin Chin, Eddie Long, Steve Fletcher, Robbie Irons, Len Thornson, Lionel Repka, Chuck Adamson, and Nick Boucher. (Courtesy of Blake Sebring.)

William "Bill" Kratzert III and Cathy Kratzert Gerring

Brother and sister Bill and Cathy Kratzert came to golf naturally, as their father was head golf pro at Fort Wayne Country Club for over 20 years. On the PGA Tour for 17 years, Bill won four tour events and is now an on-course reporter for ESPN and Turner Sports. Cathy began playing golf at age 11 and played college golf for Ohio State. Joining the LPGA, she won three times, all in 1990. While in the hospitality tent at the 1992 Sara Lee Classic, Cathy was severely burned when an alcohol-burning food warmer exploded, taking her out of competitive play for nearly three years. (Courtesy of the *Journal Gazette*.)

Bobby Milton (1928–2007)

Likely the greatest basketball player ever to come out of the city, the six-foot, one-inch Central High School forward joined the Harlem Globetrotters in 1949 as a player and later became its coach and manager. With the Globetrotters for 34 years, he played over 8,000 exhibition games in more than 100 nations, as well as on the deck of the aircraft carrier USS *Enterprise*. In one exhibition game, he set a team record by making nine baskets in a row from the half-court line. Milton was inducted into the Indiana Basketball Hall of Fame and then honored by the Globetrotters during a 2002 game at Memorial Coliseum. (Courtesy of the Indiana Basketball Hall of Fame.)

Roderick "Rod" Woodson

Woodson played a variety of football positions at Snider High School and was named a 1982 *Parade* and *USA Today* All-American. Named Indiana's "Mr. Football" in 1982, he also won both the high and low hurdles state championships in his junior and senior seasons and played varsity basketball, making all-conference his senior year. He accepted a full scholarship to Purdue where he set 13 new individual school football records, was named an All-American defensive back in 1985 and 1986, an All-American returner in 1986, and a three-time All-Big Ten first team selection. In track at Purdue, he held the record for the 60- and 110-meter hurdles and in 1984 qualified for the Olympic trials in the 110, but elected to continue his football career in the NFL after graduating from Purdue with a degree in criminal justice. A Pro Football Hall of Famer, Rod played 17 seasons in the NFL, including with the Pittsburgh Steelers from 1987 to 1996, San Francisco 49ers in 1997, Baltimore Ravens from 1998 to 2001, and Oakland Raiders from 2002 to 2003 before retiring in 2003. He was the only player in NFL history to be named to the Pro Bowl at three positions—cornerback, safety and kick returner—and holds the career record for most interceptions returned for a touchdown, with 12. In 1994, Woodson was one of only five active players named to the NFL's 75th anniversary team. Rod attended three Super Bowls and was a key factor in the Ravens winning the XXXV championship. On January 31, 2009, Woodson was elected to the Pro Football Hall of Fame in his first year of eligibility. From 1994 until 2008, Woodson held an annual youth football camp on the grounds of Snider High School. The weeklong camp, which he funded, featured current and former NFL players mentoring kids on the football skills and importance of education. He has since been an on-air analyst for the NFL Network, Big Ten Network and Westwood One, and was also hired by the Oakland Raiders as an assistant defensive-back coach in 2015. Woodson (center) is shown here in July 2009 with former mayor Win Moses (left) and Mayor Tom Henry (right). (Courtesy of the *News-Sentinel*.)

DeMarcus Beasley

Inspired by his older brother Jamar, who also became a professional soccer player, DeMarcus was a soccer prodigy at South Side High School. Beasley went to the IMG Academy, the US Soccer Federation's Residency program in Bradenton, Florida, then played for the Chicago Fire, several European teams, and the Houston Dynamos. Becoming the youngest player ever to sign a MLS contract at 16 years old, his career since joining the Chicago Fire in 2000 would be memorable enough had he not also become the only male US soccer player to play for the United States in four World Cups, including the 2014 Cup in Brazil. (Courtesy of the *News-Sentinel.*)

Sharon Wichman-Jones

At age 12, Sharon joined a swim league at Club Olympia on Goshen Road. As a junior at Snider High School, with lots of swim meets behind her, Wichman found herself training in Colorado Springs for the 1968 Olympic Games in Mexico City. She was the first Fort Wayne athlete to win an Olympic gold medal. Her event was the 200-meter breaststroke, a speed record that held for 36 years. Also at those games she swam in the 100-meter breaststroke, winning the bronze medal. After swimming competitively in the United States and internationally for another three years, she retired from the sport in 1971. (Courtesy of the *News-Sentinel.*)

Lloy Ball
Volleyball came naturally to Ball, as his father, Arnie Ball, played the game at Ball State, coached it at Paul Harding High School, and became the IPFW coach in 1981. Lloy, a gifted six-foot, eight-inch athlete, was recruited by Bobby Knight to play basketball at IU-Bloomington, but instead elected to stay in Fort Wayne and play volleyball for his father at IPFW. Ball would go on to play internationally as a setter for teams in Japan, Italy, Greece, and Russia. A member of the US Olympic Volleyball Team, he participated in four Olympics: Atlanta, Sydney, Athens, and in 2008 with the US team to take the gold medal in Beijing. (Courtesy of the *News-Sentinel*.)

Matthew "Matt" Vogel
Vogel started swimming in Fort Wayne and competing at the quarry in Huntington, Indiana, which hosted the open-water US National Long Distance Championships each summer. In 1975, after winning the 100-yard butterfly at the YMCA Nationals in Florida, he was recruited by the University of Tennessee. In his spectacular freshman season, he won the NCAA Division One 100-meter butterfly and was second in the 200-meter race. In 1976, he was off to Montreal, Canada, for the Olympic Games, where he won the gold medal in the 100-meter butterfly and a second gold as a member of the 4-by-100 freestyle relay. (Courtesy of the *News-Sentinel*.)

Eugene Parker

Raised along with two sisters by his single mother, Jessie Parker, as senior guard at Concordia Lutheran High School in 1974 he averaged 29 points per game. Parker then received a scholarship from Purdue, where he studied business management and played basketball for four years, two as team captain and their 1976 MVP, before being drafted by the San Antonio Spurs. He later married his high school sweetheart, enrolled in Valparaiso University School of Law, and from 1980 to 1982 he acted as assistant basketball coach and graduated in 1982. Coming back to Fort Wayne, he founded Parker & Associates on the 10th floor of the Standard Federal Building (now First Source Bank) at 200 East Main Street. He began his ascent into the world of professional sports management when local star and friend Roosevelt Barnes Jr. asked him for advice on his Detroit Lions contract. In 1984, he founded his company Maximum Sports Management, with Rod Woodson, also from Fort Wayne, as his first official client. With hundreds of NFL negotiations and contracts behind him, a couple of newsworthy standouts include Deion Sanders seven-year $35-million contract with a signing bonus of $13 million in 1995, making him the highest paid defensive NFL player ever. He also handled Larry Fitzgerald's six-year $60 million contract, which made him the highest paid rookie player in the history of the NFL. Other notable clients of Parker have included Emmitt Smith, Ndamukong Suh, Hines Ward, Devin Hester, Greg Jennings, and Dez Bryant. A NFLPA-certified contract advisor, considered one of football's most influential power brokers, in 2012, Parker merged his company into the Hollywood, California, firm Relativity Sports, where he is a partner and CEO of the Relativity Football division, which represents over 80 NFL players. (Courtesy of the *Journal Gazette*.)

Mike Nutter

The president and general manager of the Fort Wayne TinCaps came to town in 1999 armed with a love of baseball and a degree in sports management from Bowling Green State University. The TinCaps, formerly the Wizards, had played in Fort Wayne since 1993 but took off under the direction of Hardball Capital, Nutter, and the new Parkview Field, which opened in 2009. Under Nutter's direction, 2014 brought a new attendance record of over 411,000 through the turnstiles and the Ballpark of the Year award from *Ballpark Digest*. (Courtesy of the *Journal Gazette*.)

Dorothy "Dottie" Wiltse-Collins (1923–2008)

Raised in Inglewood, California, Dottie played baseball and at 12 led her team to the Southern California Girls Softball Championship. Beginning in 1943, she pitched for the All-American Girls Professional Baseball League, and she moved to Fort Wayne in 1945 as lead pitcher for the Fort Wayne Daisies. They played at North Side Field, Dwenger Field, and finally at a new larger facility in Memorial Park to crowds of over 3,000 fans. Dottie pitched underhand, sidearm, and overhand, setting one record after another before retiring in 1950. In the 1992 Penny Marshall movie *A League of Their Own*, Geena Davis played the role of Dottie. (Courtesy of ACFWHS.)

BIBLIOGRAPHY

Allen County Photo Album 1852–1954. Fort Wayne, IN: *News-Sentinel*, 2008.

Allen County Photo Album 1955–1959. Fort Wayne, IN: *News-Sentinel*, 2009.

Ankenbruck, John. *Twentieth Century History of Fort Wayne*. Fort Wayne, IN: Twentieth Century Historical Fort Wayne, Inc., 1975.

Beatty, John D. and Robb, Phyllis. *History of Fort Wayne and Allen County, Volumes 1 & 2*. Evansville, IN: M.T. Publishing Company, INC., 2006.

Beatty, John D. *Historical Sources of Fort Wayne, Indiana*. Fort Wayne, IN: Allen County Public Library, 2000.

Bradley, George K. *Fort Wayne's Trolleys*. Chicago, IL: Owen Davies, 1963.

Bushnell, Scott M. *Historic Photos of Fort Wayne*. Nashville, TN: Turner Publishing Company, 2007.

Griswold, B.J. *The Pictorial History of Fort Wayne, Indiana, Volumes 1 & 2*. Chicago, IL: Robert O Law Company, 1917.

———. *Builders of Greater Fort Wayne*. Fort Wayne, IN: Fort Wayne Paper Box Co., 1926.

Hawfield, Michael C. *Fort Wayne Cityscapes*. Northridge, CA: Windsor Publications, 1988.

Mather, George R. *Frontier Faith*. Lima, OH: Fairway Press, 1992.

———. *The Best of Fort Wayne, Volume One*. St. Louis, MO: G. Bradley Publishing, Inc., 2000.

———. *The Best of Fort Wayne, Volume Two*. St. Louis, MO: G. Bradley Publishing, Inc., 2001.

Roberts, Rachel Sherwood. *Art Smith: Pioneer Aviator*. Jefferson, NC: McFarland & Company, Inc., 2003.

The Bicentennial Heritage Trail Committee. *On the Heritage Trail*. Fort Wayne, IN: ARCH, Inc., 1994.

INDEX

INDEX

AN IMPRINT OF ARCADIA PUBLISHING

Find more books like this at
www.legendarylocals.com

Discover more local and regional history books at
www.arcadiapublishing.com

Consistent with our mission to preserve history on a local level, this book was printed in South Carolina on American-made paper and manufactured entirely in the United States. Products carrying the accredited Forest Stewardship Council (FSC) label are printed on 100 percent FSC-certified paper.